SPRING TRAINING
IN
BRADENTON
AND SARASOTA

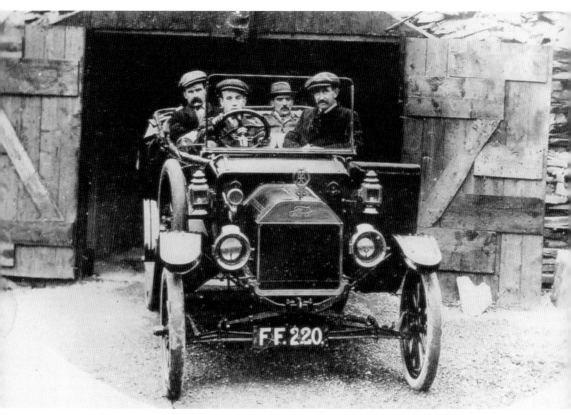

Henry Ford's automobile opened up the roads, making travel more affordable for common folk. This was a contributing factor in the Florida land boom of the 1920s. Major-league baseball teams that had been training all over the South set their sights on the Sunshine State, and cities and towns vied for their affections. (Courtesy of State Archives of Florida, *Florida Memory*.)

FRONT COVER: Red Sox manager Mike Higgins checks the stance of four-year-old Mike Hartenstein at Payne Park in Sarasota in the spring of 1957. (Courtesy of REJMJ collection.)

COVER BACKGROUND: This image depicts the Baltimore Orioles dugout at Ed Smith Stadium in Sarasota, Florida. It was taken on March 17, 2011, when the Orioles entertained the Boston Red Sox, who were bedecked in green jerseys to celebrate St. Patrick's Day. (Author's collection.)

BACK COVER: Boston Braves manager Bill McKechnie greets his latest acquisition, Babe Ruth, in the spring of 1935. (Courtesy of Boston Public Library.)

SPRING TRAINING
IN
BRADENTON
AND SARASOTA

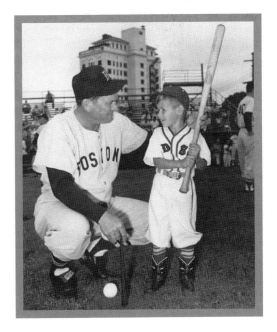

Raymond Sinibaldi

ARCADIA
PUBLISHING

Published by Arcadia Publishing
Charleston, South Carolina

Printed in the United States of America

Library of Congress Control Number: 2012949199

For all general information, please contact Arcadia Publishing:
Telephone 843-853-2070
Fax 843-853-0044
E-mail sales@arcadiapublishing.com
For customer service and orders:
Toll-Free 1-888-313-2665

Visit us on the Internet at www.arcadiapublishing.com

To Lynda for 20 billion years and 20 billion more . . .
Non dimenticherò mai quanto siete amati

CONTENTS

ACKNOWLEDGMENTS

I am grateful and heartened by the people who lent a hand to this project: my good friend Kerry Keene, whose special craziness made this a better tome; Pam Gibson of the Manatee County Library and Cindy Russell of the Manatee Historical Records Library; Jenny Ambrose and Freddy Berowski of the National Baseball Hall of Fame; Jamie Wisner, whose talent and generosity made my work better; Paula Homan of the St. Louis Cardinals Hall of Fame Museum for her tenacity in the search, Dan Rea and Sarah Coffin of the Boston Red Sox; the Atlanta Braves; Jeff LaHurd for his great work and his assistance with the Sarasota County History Center; the Boston Public Library; Wendell Smith; the SABR Bio Project; the ever cheerful Kellie Melanson; Monica Barlow and the Orioles staff at Ed Smith Stadium; Maureen McCormick of the Anna Maria Island Historical Society; former Red Sox pitchers Bill Monbouquette and Frank Sullivan; baseball-reference.com; retrosheet.org; ootpdevelopments.com; whenitwasagame.net; sarasotahistoryalive.com; at Arcadia, Maggie Bullwinkle as well as Ryan Easterling, who had an unending reservoir of patience; and all the folks who generously shared their love of the game through their work.

Unless otherwise noted, images appear courtesy of Manatee County Library (MCL), the Sarasota County History Center (SCHC), Boston Public Library (BPL), and the RachaelElizabethJoshMargeauxJulie collection (REJMJ).

INTRODUCTION

As much as any one man, Henry Ford was responsible for spring training in Florida. His wonderful invention of the automobile opened up the Sunshine State for the common man. Previously accessible by boat or train, and thus exclusively by the wealthy, the auto opened a new world to regular Americans, and Florida was destined to be a part of it. The 1920s were roaring, opportunities abounded, and Florida cities and businessmen were determined to roar with them.

Bradentown, which officially became Bradenton in 1925, stepped first into the foray of the Roaring Twenties when it built a ballpark on Ninth Street to lure the St. Louis Cardinals for their spring training. The Cardinals spent the majority of their springs in Texas but thought it was time to give Florida a whirl. The new park garnered a lot of attention in St. Louis, and in January 1923 stories appeared on the city's sports pages with nothing but words of praise for the new facility. The greenskeeper from the golf course across the street was hired to lay the infield, and it was clear that Bradentown was leaving no stone unturned as it constructed "the greatest baseball training camp in the entire country."

St. Louis skipper Branch Rickey sang the praises of the state-of-the-art facility, saying, "There isn't another spot in the south that equals Bradentown . . . the new clubhouse equals Sportsman Park and the grass is so smooth I could sink a 40 foot putt with my eyes closed." The new clubhouse was indeed of major-league quality, at 60 feet by 35 feet with 60 lockers, five showers, and a handball court just outside. Rickey was convinced that the "warm weather will aid the pitchers," and Cardinals owner Sam Breadon was so excited that he proclaimed, "These fine training grounds are sure to turn up a bunch of World Series winners."

As Gutzon Borglum was announcing his plans for Stone Mountain in Georgia and Howard Carter was excavating the chamber of King Tut's tomb, the St. Louis Cardinals were trickling in to the lovely Manavista Hotel that was, according to the *Bradenton Herald*, "just a hop skip and a jump from the shores of the Manatee River." A six-game schedule was in place, and opening-day anticipation was heightened when W.A. Manning and Harry Land of the Bradentown Board of Trade invited commissioner Kenesaw Mountain Landis, "the supreme arbitrator of all things baseball," to attend the festivities. Landis was the principle speaker at the annual banquet of 125 members of the board of trade. Arriving by plane, Landis made his way to the game following his speech.

Bradentown was "baseball crazy," and the fanfare was commensurate with the mood, as plans were made to actually take "moving pictures" of the players. Alas, despite the unmatched facilities, the Cardinals were unable to, as the *Herald* put it, "turn up a bunch of World Series winners." After just two years, they were bound for Stockton, California.

A few miles south in Sarasota, Calvin and Martha Payne donated 60 acres of land to the city to be used for park purposes. The city fathers took their opportunity to cash in on the roar of the 1920s as well, bringing the Ringling Brothers Circus to the park. What became a marriage

of the circus, baseball, and entrepreneurialism played out in the friendship of circus magnate John Ringling and New York Giants manager John McGraw, and the Giants were on their way to Sarasota in the spring of 1924. The success of the Cardinals in Bradentown in 1923 was not lost on the astute eyes of these two giants of the entertainment industry.

The inaugural season, 1924, was a success. Marked with appropriate fanfare and with National League president John Heydler tossing out the first pitch, the locals turned out in droves throughout the spring. McGraw and his Giants endured the logistical nightmare of not having quality hotel space and agreed to return in 1925.

With the attention brought to Sarasota throughout the Northeast, particularly in New York, the city nearly doubled in population by the following spring. Charles Ringling opened the Sarasota Terrace Hotel within walking distance of Payne Park, and John McGraw saw an opportunity for himself to personally cash in as well. Working with realtor A.S. Skinner, McGraw lent his name and resources to the development of Pennant Park. Skinner ran ads in the *Sarasota Herald* urging one and all to "join [McGraw] in making Pennant Park." Calling it "a proposition of national importance and drawing national interest" and claiming that "a big proposition should be handled in a big way," he proclaimed it a "matter of civic pride" to participate.

Participation was ferocious and attracted some of the city's biggest names, including Calvin Payne and Charles Ringling; however, turning a quick profit drove the project more than a desire to make Sarasota Bay a permanent home for spring training. At times, lots sold several times a day in an atmosphere that resembled the floors of Wall Street. McGraw's energies in Sarasota seemed to be drawn more towards Pennant Park than Payne Park, and he left the baseball matters to his coaching staff.

In September 1926, the Great Miami Hurricane ripped through the tip of Florida and swept across the Gulf, hitting the Florida Panhandle and killing between 300 and 800 people, leaving thousands homeless, and causing $105 million in damage. If that storm occurred today, estimates of up to $150 billion are reasonable taking into account coastal development. Although Sarasota escaped the storm's direct fury, it effectively put an end to the Florida land boom and thus to McGraw and company's Pennant Park. The Giants returned for the 1927 spring, but in 1928 they were bound for Augusta, Georgia, leaving Payne Park to the Indianapolis Indians of the American Association.

When Tom Yawkey purchased the Red Sox in 1933, he returned major-league baseball to Payne Park and Sarasota in the springtime. The Sox arrived in the first year of Pres. Franklin D. Roosevelt's administration and did not leave until the administration of George H.W. Bush. They changed their color from red to white, but, except for one year, "the Sox" occupied Payne Park for the remaining 55 springs of its life.

The White Sox bid adieu to Payne Park in 1988 and headed a few miles west to Ed Smith Stadium, the brand-new facility on Twelfth Street. They remained there for nine years before leaving for Tucson. The Cincinnati Reds moved from the "Strawberry Capital of the World," Plant City, Florida, to Ed Smith Stadium in 1999. Eventually, they succumbed to the allure of the desert as well, moving into a new facility in Goodyear, Arizona, in 2010.

Following the Reds departure, Sarasota and the Red Sox explored a reunification. Boston was seeking their own new facility, and Sarasota was entertaining the possibility of providing them with one. However, in the midst of the real estate collapse of 2008, an agreement could not be

reached, and Fort Myers, not wanting to lose the Red Sox to their neighbors up the coast, offered the Red Sox a deal they simply could not refuse. Sarasota settled on a $31 million renovation of Ed Smith Stadium and welcomed the Baltimore Orioles to town in 2011. In the 64-year history of spring training at Payne Park, three teams trained there—the same number that have trained at Ed Smith Stadium since its birth in 1989.

It would take more than a half century for Bradenton to achieve the spring-training stability Sarasota enjoyed. Following the Cardinals departure, the Philadelphia Phillies stepped into the breach, and their arrival in 1925 left no doubt that there would be no World Series winners out of Bradentown (by then Bradenton) any time soon. The Phillies had a choke hold on the cellar of the National League and held it for six years, finishing last for four of them and next-to-last the other two. They departed in 1927, opening the door for the 1928 arrival of the Boston Red Sox.

It was an exchange of doormats, as the Red Sox were actually worse than the Phillies. Since 1922, they had finished in last place five times and lost 105, 107, and 103 games, respectively, in the three seasons prior to their arrival at the recently renamed Ninth Street Ballpark. Nonetheless, the city was thrilled at the infusion of business their presence would bring and was poised to welcome owner Bob Quinn and his Red Sox with great fanfare. The headline of the *Bradenton Herald* on February 21, 1928, proclaimed, "All Bradenton to Greet Red Sox on Wednesday," and many local businesses ran advertisements welcoming the team.

Mayor Gordon Knowles presented the key to the city to Quinn and manager Bill Carrigan with the word "Friendship" on it. Nine games were scheduled at the Ninth Street venue, and 900 patrons were on hand to watch the Cardinals beat the Sox 8-1 in the first game of the spring. Unfortunately, the "friendship" lasted but two years, as Quinn and his Red Sox headed north to the Florida Panhandle to train in Pensacola in 1930. This triggered the return of Bradenton's original spring-training club, the St. Louis Cardinals.

The second incarnation of the Cardinals at the Ninth Street Park (by then called City Park) ran from 1930 through 1936, and Cardinals owner Sam Breadon's forecasted World Series winners did in fact turn up this time. The Cards won the World Series in 1931 and again with the fabled "Gas House Gang" in 1934. In fact, the city of Bradenton played a role in that moniker being attached to the squad. Ace pitcher Dizzy Dean was so enamored with Bradenton that he purchased a gas station, where he and many of his teammates spent time when not at the ball field, bringing a gasoline smell back to the field. A payment of $5,000 by the community of Daytona Beach lured the Cardinals away from Bradenton in 1937, and the Boston Braves, then known as the Bees, arrived for the springs of 1938, 1939, and 1940. But with the country on the brink of war, major-league spring ball left Bradenton and did not return until the Bees (now back to being the Braves) came back in 1948.

With the Braves came an immediate championship, as they won the National League pennant in 1948. They remained for 15 springs, during which they became one of the league's premier franchises. Moving to Milwaukee in 1963, they won pennants in 1957 and 1958, playing the Yankees in both World Series and winning in 1957. The park was called Braves Field until their departure, which coincided with the induction of longtime Manatee County resident Bill McKechnie into the National Baseball Hall of Fame. The stadium still bears his name today.

The spring of 1950 brought new challenges for the Braves, the city of Bradenton, and baseball after the Braves signed former Negro League star Sam Jethroe. They were the fourth team to add

a black player to the roster but the first to face the segregation of the South. The three teams that preceded them circumvented the issue: the Dodgers had trained in Cuba and in the Dominican Republican before constructing their self-contained complex in Vero Beach in 1949, the St. Louis Browns trained in California after they signed Hank Thompson in 1948, and the Giants trained in Arizona when they signed Monte Irvin and acquired the same Hank Thompson in 1949.

Bill Bruton followed Jethroe to the Braves in 1953, and in 1954 Henry Louis Aaron arrived. The "tolerance" of integration on the field did not translate off the field, as these players were not allowed to stay in the hotel with their teammates and were given accommodations in a rooming house in the "colored" section of the city. The stands at the ballpark featured a "colored" section, fully equipped with separate drinking fountains, bathrooms, and concession stands. Slow as they may have been to react, the rising tide of the Civil Rights Movement pushed the Braves to finally apply a bit of financial pressure, and they opted for motels in Palmetto rather than in downtown Bradenton; however, Lulu Mae Gibson's rooming house was the residence of choice for the black members of the Braves throughout the 1950s.

Sarasota avoided this challenge, as the Red Sox did not integrate their team until the year after they left Sarasota. White Sox owner Bill Veeck, who in 1947 signed Larry Doby, the first black player in the American League, unsuccessfully implored Commissioner Landis to sign blacks during World War II. He opted to stay in a motel on Route 301 in his constant push to integrate Sarasota. He continued to push until the walls eventually fell.

When the Braves vacated Bradenton, the Kansas City Athletics arrived, and in days reminiscent of the late 1920s, Bradenton was again paired with a league doormat; however, in the six years the A's trained at McKechnie Field, a number of their players began careers that would shape the face of baseball well into the 21st century. Kansas City's McKechnie years laid the foundation for the Oakland A's, who won three straight World Series, in 1972, 1973, and 1974.

Oakland became the third home for the Athletics, who began in Philadelphia in 1901. With the move to Oakland came a move to Arizona for spring training. In 1969, the Pittsburgh Pirates moved into McKechnie Field. The Pirates have been there ever since, and despite pitfalls, pratfalls, horrendous conditions, and sparse attendance, they have endured, establishing a relationship with the community that still thrives today.

The Pirates and Bradenton have a lease that runs until 2037, and in Sarasota the Baltimore Orioles lease does not end until 2040, so it is clear that both cities and franchises will celebrate the 100th anniversary of spring training in these cities. In the case of the Pirates, it will be in the very same ballpark—the oldest operating spring-training facility in all of baseball.

BILL "THE DEACON" MCKECHNIE

William Boyd McKechnie was involved in baseball as a player, manager, and coach from 1906 until 1953. Entering the game at a time when most players were hard-drinking, hard-living individuals, "The Deacon" was a sharp contrast to most around him. His baseball career took him through 11 different cities and finally to his last home in Bradenton, where, following his Hall of Fame induction, the city fathers named the park after him. (Courtesy of National Baseball Hall of Fame.)

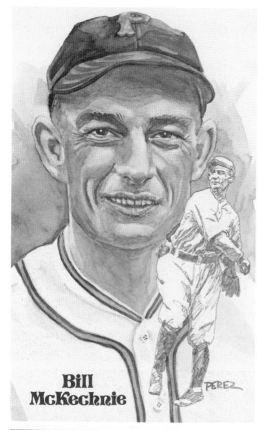

Bill
McKechnie

PEREZ

Raised in Wickinsburg, Pennsylvania, right outside of Pittsburgh, Bill McKechnie made his major-league debut with the Pirates in 1907. The switch-hitting infielder only played in three games that year and headed down to the minor leagues. He returned in 1910 and played with the Pirates through 1912. He made six more stops in his playing career, which he closed back with the Pirates in 1920. (Courtesy of REJMJ.)

McKechnie was picked up by the Boston Braves from the Pirates in 1912. He made his way to Boston but played only one game for the team he would manage for seven years two decades later. In that one game, he played outfield and batted five times without a hit, but he did walk and score a run. (Courtesy of Library of Congress.)

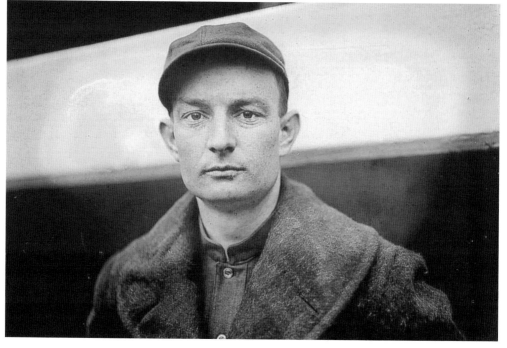

McKechnie had stops with the New York Giants in 1913 and again in 1916. In July 1916, he was traded along with fellow Hall of Famers Edd Roush and Christy Mathewson to the Cincinnati Reds. Mathewson became a charter member of the National Baseball Hall of Fame in 1936. Roush and McKechnie were both inducted in 1962. (Courtesy of Library of Congress.)

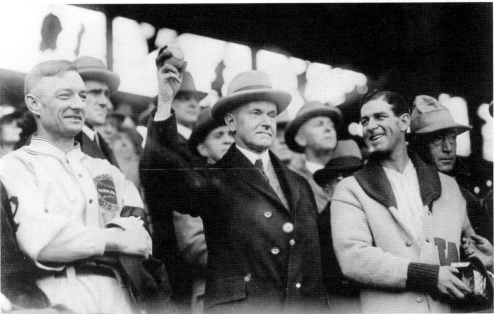

Pirates manager Bill McKechnie (left) smiles as Pres. Calvin Coolidge readies himself to fire the first pitch of game three of the 1925 World Series. To the right of the president is Senators manager Bucky Harris, and on the far right is baseball commissioner Kenesaw Mountain Landis. The Senators beat the Pirates in game three, but the Pirates won the series. (Courtesy of Library of Congress.)

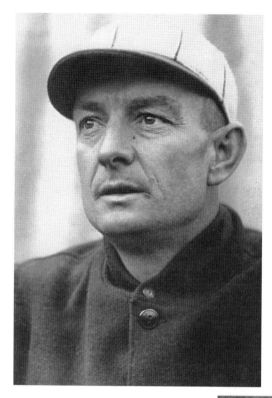

The Pirates fired McKechnie (left) following a third-place finish in 1926, and he spent 1927 out of baseball; however, in 1928, he signed with St. Louis to replace catcher-manager Bob O'Farrell. The move paid immediate dividends, as the Deacon piloted the Cardinals to the National League pennant, winning 95 games. Yet, after they were swept by the Yankees in the World Series, McKechnie was fired and replaced with Billy Southworth. The next year, Southworth had the defending National League champs stumbling at 43-45 when Cardinals ownership admitted their mistake and reinstated McKechnie, who guided St. Louis to a 34-29 record the rest of the year to finish with a respectable 78-74 record. McKechnie (below, in 1957) spent his last days on the field in a Cardinals uniform as an unofficial coach in spring training. (Both courtesy of REJMJ.)

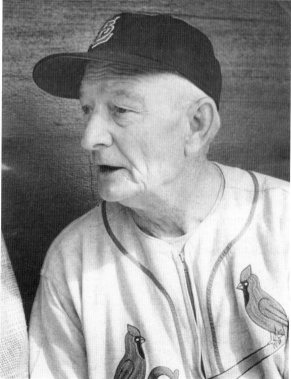

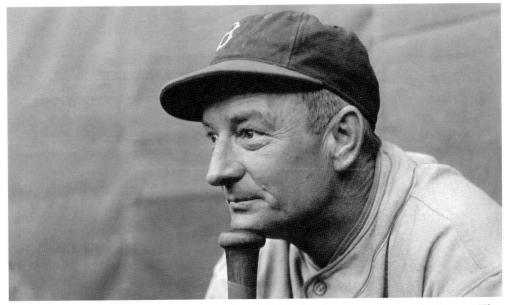

In 1930, Boston Braves owner Emil Fuchs hired Bill McKechnie to take over the Braves. This was no small task, as they had been among the worst teams in baseball for nearly 15 years. The Braves had not had a winning season since 1921 and had finished in last or next-to-last place nine times. Included in that string of futility were four years of 100 or more losses, three of which were in a row. Above, McKechnie strikes a thoughtful pose as he eyes his charges on the diamond. Below, he staves off an April chill in the Braves Field dugout with a look that reads, "What have I got myself into?" In his first year as the Braves manager, they went 70-84, their best finish in six seasons. (Both courtesy of BPL.)

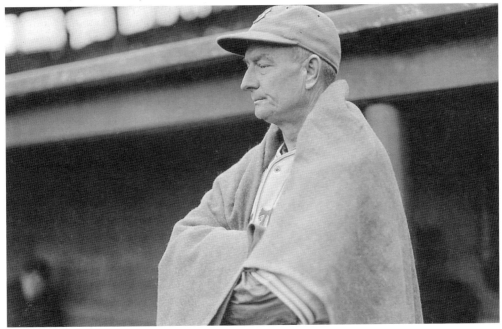

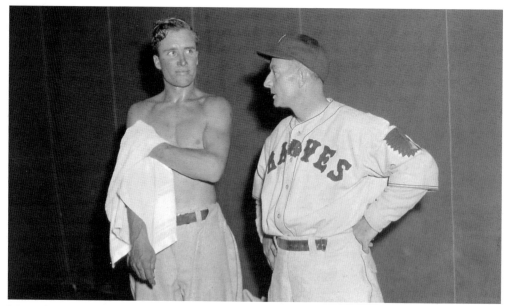

McKechnie confers with his star outfielder Wally Berger, who played in the first all-star game in 1933 and was McKechnie's best player with the Braves. A .300 hitter with power, Berger led the National League in home runs and RBIs in 1935. The Deacon thought so highly of the four-time all-star that he acquired him from the Giants when he took over the Reds in 1938. (Courtesy of BPL.)

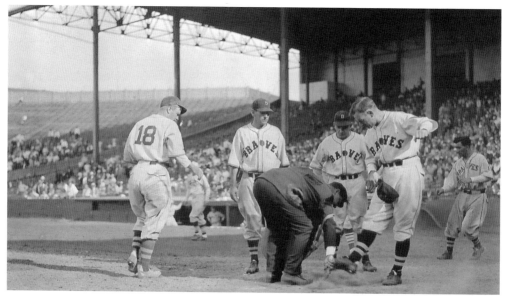

Usually mild-mannered, McKechnie was also a competitor and could get fiery. He was ejected from 22 games as a manager, seven of those with the Braves. Here, on August 18, 1933, he disputes a call at home plate in a game against the Cubs. Pitcher Huck Betts (18) looks on as McKechnie lets umpire Jack Powell know what he thinks of his judgment. McKechnie lost the argument and was ejected in a 4-3 Braves loss. (Courtesy of BPL.)

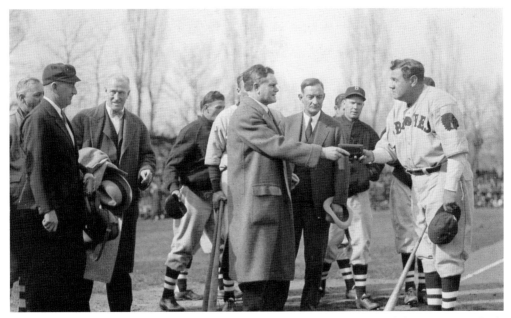

Bill McKechnie was Babe Ruth's final manager, and the quiet Deacon and the uproarious Ruth did not mesh well in Boston. Ruth's desire to manage was well known, and many, including Ruth, believed that his signing with the Braves in 1935 was a prelude to taking the reins as club manager. This created a rift between the two men, and Ruth's decline as a player made things all the more difficult. With Ruth's skills considerably diminished, McKechnie later claimed that three different pitchers asked that Ruth not play behind them when they pitched. Still admired and adored by fans, Ruth is seen above receiving the key to the city of Worcester, Massachusetts, before a preseason exhibition game at Holy Cross College. Below, Ruth stands between Red Sox manager Joe Cronin (left) and McKechnie in the dugout before a city series game between the Red Sox and Braves. (Both courtesy of BPL.)

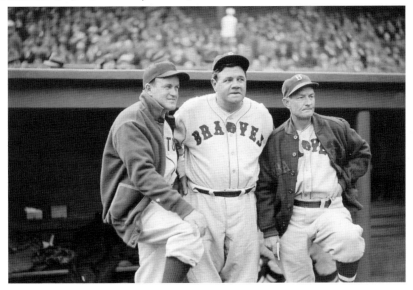

In 1935, the Boston Braves had the worst record in baseball history, and in an effort to turn their fortunes they changed uniforms and their name. The Bees was selected in a fan poll as the new moniker. McKechnie is seen above posing in his Bees uniform with a rival from the Cubs. They were called the Bees through 1940, returning to the Boston Braves in 1941. (Courtesy of BPL.)

The Braves fired McKechnie following the 1938 season, and he was hired to manage the Cincinnati Reds. The Deacon and the Reds celebrated baseball's 100th anniversary season of 1939 (note the patch on the left sleeve) by winning the National League pennant. In doing so, McKechnie became the first manager in baseball history to win a pennant with three different teams. (Courtesy of BPL.)

In 1940, McKechnie's Reds won their second pennant in as many years, winning 100 games. Having been swept by the Yankees in the 1939 World Series, the Reds defeated the Tigers in seven games in the Fall Classic of 1940, McKechnie's second world championship as manager. Here, he shares a moment with a batboy before a game at Braves Field in 1940. (Courtesy of BPL.)

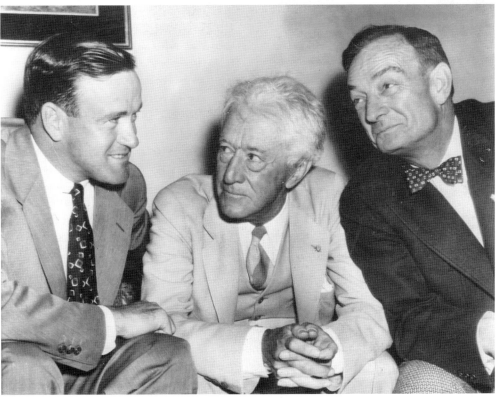

American League manager Joe Cronin (left) and National League skipper Bill McKechnie (right, with his ever-present bow tie) meet with Commissioner Landis prior to the 1940 All-Star Game in St. Louis. McKechnie wore the same purple tie through an 11-game Reds winning streak in September 1940. It was put on display in the Hall of Fame the next winter following the Reds world championship. (Courtesy of REJMJ.)

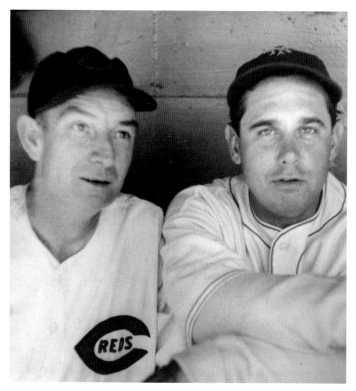

Here, McKechnie shares a moment with New York Giant great Bill Terry, who played 14 years with the Giants and compiled a .341 lifetime batting average. Terry hit .401 in 1930, making him the last National League player to crack the .400 mark. Terry and McKechnie are both in the Hall of Fame. (Courtesy of REJMJ.)

McKechnie managed the Reds for nine seasons. In 1947, he joined player/manager Lou Boudreau's Cleveland Indians staff as a bench coach. With Boudreau playing shortstop everyday, he turned a lot of the managerial duties over to the likeable Deacon, who played a key role as Cleveland won the 1948 American League pennant, defeating the Red Sox in a one-game playoff before beating the Braves in the World Series. (Courtesy of REJMJ.)

BILL "THE DEACON" MCKECHNIE

In 1949, Bill McKechnie retired from Boudreau's coaching staff and took up tomato farming in Palmetto, just north of Bradenton. He is seen here checking his crop in December 1949 just after announcing he was through with baseball. His retirement proved to be short-lived; three years later, he was coaxed back to the diamond when Boudreau became the manager of the Boston Red Sox. (Courtesy of REJMJ.)

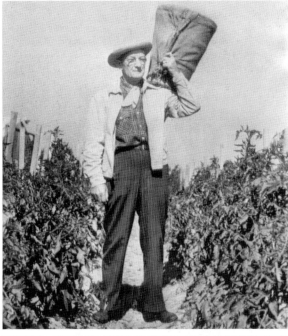

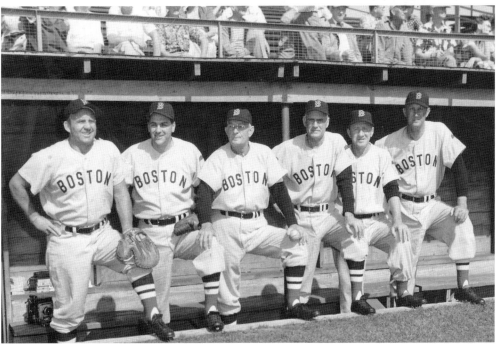

In 1952, McKechnie's old friend Lou Boudreau took the helm for the Red Sox and brought McKechnie out of retirement to serve as his pitching coach. The Red Sox coaching staff poses here in the dugout at Payne Park in Sarasota in 1952. They are, from left to right, Oscar Melillo, "Handsome Lou" Boudreau, McKechnie, Earl Combs, George Susce, and Paul Schreiber. Bill McKechnie retired again to Bradenton following the 1953 season. (Courtesy of REJMJ.)

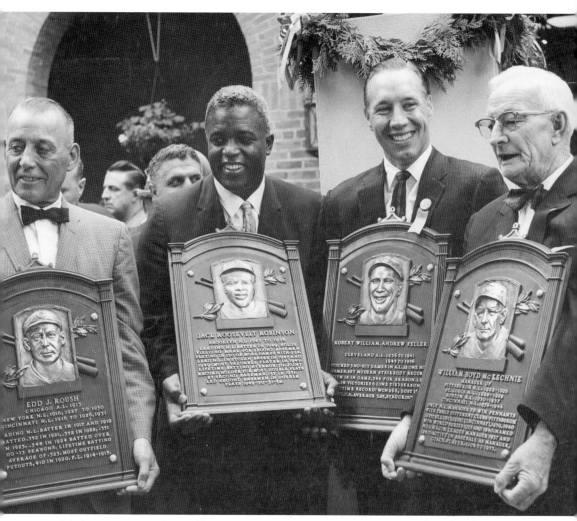

Bill McKechnie (right) was inducted into the National Baseball Hall of Fame in Cooperstown, New York, in 1962, along with, from left to right, Edd Roush, Jackie Robinson, and Bob Feller. Roush and the Deacon were teammates on four different teams: Indianapolis and Newark in the Federal League and the New York Giants and Cincinnati Reds in the National League. The class of 1962 was historic, with the election of Jackie Robinson and Bob Feller as well as Roush and McKechnie. Robinson broke the color barrier in 1947 and is the only player in major-league history to have his number (42) retired throughout major-league baseball. One day each year, he is honored with every player on every team wearing his famous number. Feller, one of the greatest pitchers in history, has the distinction of having lived longer than anybody as a Hall of Famer. Inducted in 1962, he lived for 48 more years in that capacity before his death in 2012. (Courtesy of National Baseball Hall of Fame.)

FROM BRADENTOWN BALL PARK TO McKECHNIE FIELD

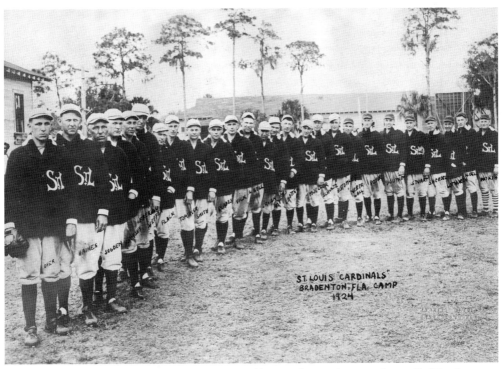

The Cardinals arrived in Bradentown in 1923 and began play at what was then called Bradentown Park. The site would be known as City Park, the Ninth Street Park, and Braves Field before being named in honor of Manatee County resident and Hall of Famer Bill McKechnie in 1962. Today, McKechnie Field is the oldest operating spring-training facility in the country. (Courtesy of St. Louis Cardinals Hall of Fame Museum.)

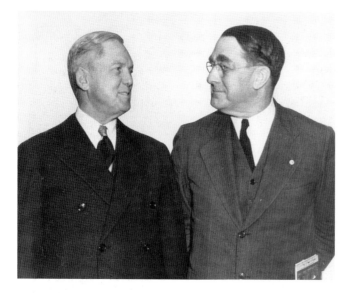

Cardinals owner and president Sam Breadon (left) brought the Cardinals to Bradentown in 1923 under manager Branch Rickey (right), who managed the Cards from 1919 through 1925. Rickey went on to become one of the most innovative executives in baseball history, inventing the modern farm system. Branch Rickey also signed Jackie Robinson, transforming baseball forever. (Courtesy of REJMJ.)

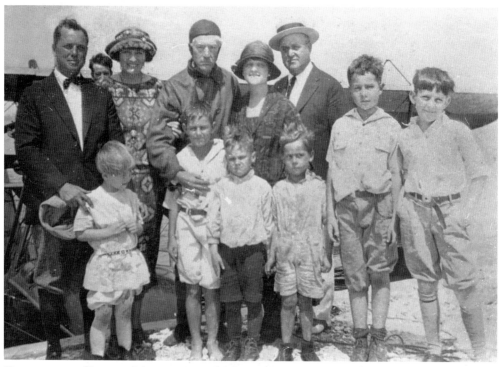

Commissioner Kenesaw Mountain Landis (second row, third from left) was on hand for the opening of Bradentown Park in March 1923. His plane actually landed in the outfield, and within minutes he was posing with the Mayor E.P. Green (straw hat) and the Vanderipe family. Landis has his arm around young Henry Vanderipe, and to the right of Henry is his cousin William. The Vanderipes were a pioneering Bradenton family, arriving in 1852 and establishing a cattle business. (Courtesy of MCL.)

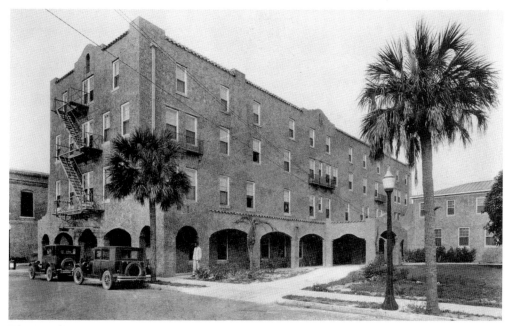

The Hotel Manavista opened its doors in 1906, and by the 1920s the *Bradenton Herald* called it the "center of cultural and societal activities." Located on the Manatee River between Turner and Pine Streets (now Third and Thirteenth Streets), it featured an alligator farm. It was the spring home of the Cardinals in their early years in Bradenton. Their arrival played a role in a $150,000 renovation that took place in the fall of 1924. (Courtesy of MCL.)

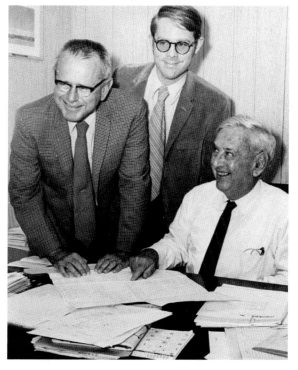

The Beall family—from left to right, Egbert, R.M., and Robert—had a business dating back to pre-World War I Bradenton. Begun as the Dollar Limit Store, Robert renamed it the V [Five] Dollar Limit Store in the early 1920s. Robert played an active role in bringing every team that has trained in Bradenton to town. (Courtesy of MCL.)

The Phillies trained in Bradenton in 1925, 1926, and 1927, and outfielder George Washington Harper was so enamored with the area that he became a local realtor. A friend of Brooklyn pitcher and area resident Bill Doak, Harper went to work for the Dowd and Hope Company, which was developing the Bradenton Beach area of the city. (Courtesy of REJMJ.)

In 1929, teenage phenom Joe Cicero was in Bradenton trying to make the Red Sox squad. The Atlantic City High School product made his debut in September of that same year. A first cousin of Hollywood idol Clark Gable, Cicero's career encompassed only 40 games in three years, 28 of them with the Red Sox. He holds the major-league record for the longest time between big-league appearances, from 1930 until 1945. (Courtesy of Boston Red Sox.)

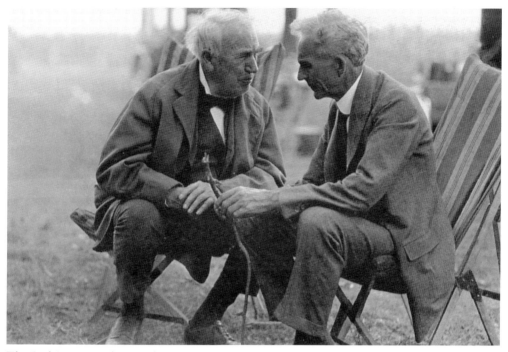

The Red Sox arrived in Bradenton in March 1928 to great fanfare. Seen above in Bradenton on the day of the Red Sox arrival are two high-profile Americans, Thomas Edison (left) and Henry Ford; however, it was Bob Quinn's Red Sox who were given the key to the city. Quinn's ineptitude on the field is illustrated in the rare photograph below, showing him leaping to his left for a ball that is on the ground by his right foot (see arrow). Quinn's baseball ineptitude translated to his ownership as well, for during his 11 years as the team's owner they finished in last place eight times, in seventh place twice, and in sixth place once. His Red Sox lost more than 100 games five times, including 111 in 1932. (Above, courtesy of REJMJ; below, JJC collection.)

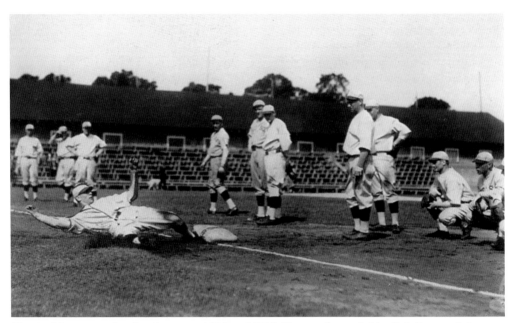

The Red Sox trained in Bradenton in 1928 and 1929. Here, utility infielder Bob Reeves slides into first base during a 1929 sliding drill while his teammates look on. Reeves, known as "Gunner" for his strong throwing arm, played three years with the Red Sox and gained a reputation for always being upbeat and positive, which was not an easy task on some very bad Red Sox teams. (Courtesy of Library of Congress.)

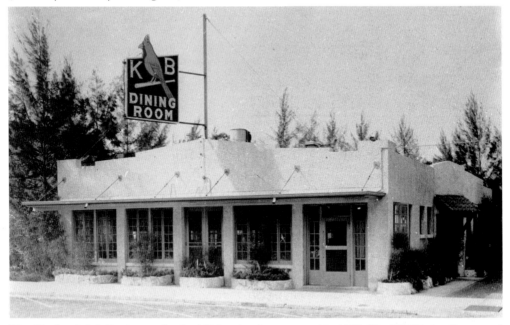

The Cardinals left Bradenton for the 1925 spring but returned in 1930. The KB Dining Room and Coffee Shop, on Thirteenth Street West, took full advantage of their return. Its sign, seen here around 1930, was adorned with the time-honored logo of the Cardinals. (Courtesy of MCL.)

St. Louis pitcher Bill Doak was happy the Cardinals chose Bradentown as their spring home, for it was there he met his wife, Jessie, and settled into a home on Twenty-fourth Street. "Spitting Bill" pitched 13 years with the Cardinals, winning 144 games. He was a 20-game winner in 1920 and twice led the league in ERA. He called Bradenton home until his death in 1954. (Courtesy of MCL.)

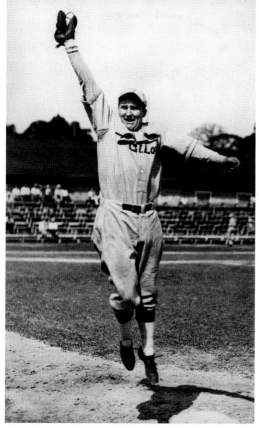

James Anthony "Ripper" Collins, seen here snagging a ball at Ninth Street Park in 1934, played six seasons with the Cardinals and was their regular first baseman from 1932 through 1935. In 1934, the three-time all-star led the National League in home runs and hit .367 in the World Series to lead the Cardinals to victory over the Detroit Tigers in seven games. (Courtesy of St. Louis Cardinals Hall of Fame Museum.)

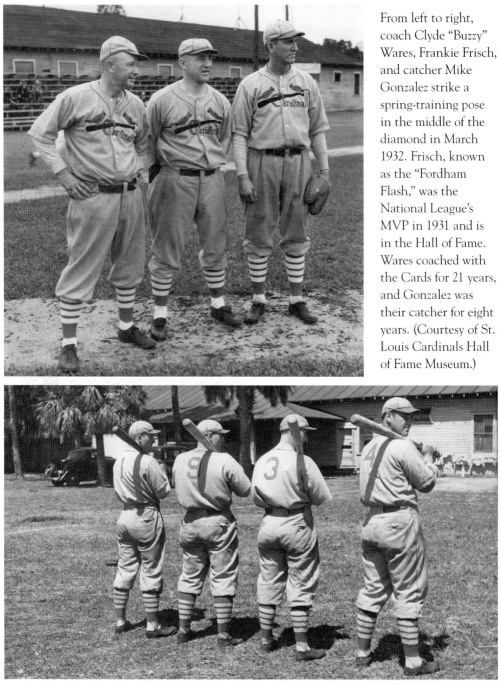

From left to right, coach Clyde "Buzzy" Wares, Frankie Frisch, and catcher Mike Gonzalez strike a spring-training pose in the middle of the diamond in March 1932. Frisch, known as the "Fordham Flash," was the National League's MVP in 1931 and is in the Hall of Fame. Wares coached with the Cards for 21 years, and Gonzalez was their catcher for eight years. (Courtesy of St. Louis Cardinals Hall of Fame Museum.)

Four members of the 1934 "Gashouse Gang" pose with their numbers to the camera at the beginning of the spring training. It was only the third year the Cardinals had numbers on the backs of their jerseys. They are, from left to right, Johnny "Pepper" Martin (1), Bill DeLancey (9), Frankie Frisch (3), and George "Kiddo" Davis (4). They went on to win the World Series that year. (Courtesy of St. Louis Cardinals Hall of Fame Museum.)

One of the game's great characters, Jay Hanna "Dizzy" Dean, is seen here in spring training in 1934. The National League MVP in 1934, he was 30-7 and won two games in the World Series, including a shutout in game seven. His brother, Paul "Daffy" Dean, won the other two. Dizzy Dean bought a home and a gas station in Bradenton, where he used to spend time when he was not at the ballpark. He often brought the scent of gasoline back to the park, which contributed to the team's nickname, the "Gashouse Gang." His teammate Pepper Martin said of him, "When ole Diz was out there pitching, it was more than just another ball game. It was a regular three-ring circus, and everybody was wide awake and enjoying being alive." Dean was inducted into the Hall of Fame in 1953. (Both courtesy of Manatee County Historical Records Library.)

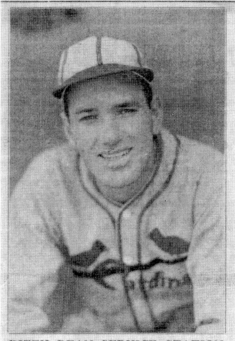

HISTORY OF BRADEN CASTLE, FLORIDA

DIZZY DEAN SERVICE STATION
We Specialize In Lubrication - Complete Service
RADENTON, FLA. PHONE 39-881

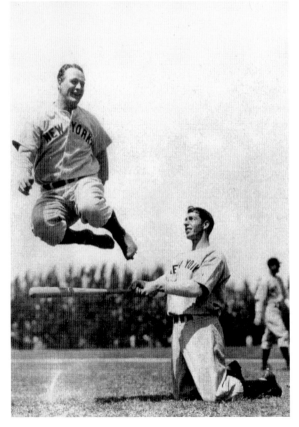

George Litchfield (above, center), the manager of the Dixie Grande Hotel, points to a picture of Paul Derringer (left) as they reminisce about Derringer's pitching days with the Cardinals. Derringer came to Bradenton with St. Louis in 1931, 1932, and 1933. He went 18-8 as a rookie and had 223 career wins. "Duke" Derringer retired to Sarasota after his playing days. The Dixie Grand was torn down in 1974. (Courtesy of MCL.)

Lou Gehrig (left, jumping) and Joe DiMaggio (kneeling), two of the game's all-time greats, played together from 1936 to 1939. They created quite a stir at Bradenton's City Park when the Yankees came to play the Boston Bees on St. Patrick's Day in 1939. Hitting fourth and fifth in the lineup, each player got a hit, but the Bees won 9-6. (Courtesy of REJMJ.)

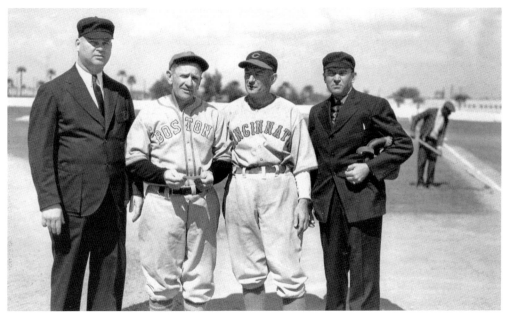

Charles "Casey" Stengel replaced Bill McKechnie as the Bees manager in 1938. Here, the two friends meet with the umpires at home plate before a 1940 spring-training game in Bradenton. In 1962, McKechnie told Fred Lieb in the *Sporting News*, "There always was a warm bond between Charley and myself, I always enjoyed him." Stengel managed the Bees/Braves into the 1943 season, and the two remained lifelong friends. (Courtesy of BPL.)

Al Lopez trained with the Bees in Bradenton in 1939 and 1940. In March 1940, Lopez participated in a spring all-star game in his native Tampa to raise money for the Finnish Relief Fund. Finland had just been invaded by the Soviet Union. In a game that featured Ted Williams, Joe DiMaggio, and Jimmie Foxx, Lopez was the hero, scoring the winning run in the ninth inning. The game raised $22,000. (Courtesy of BPL.)

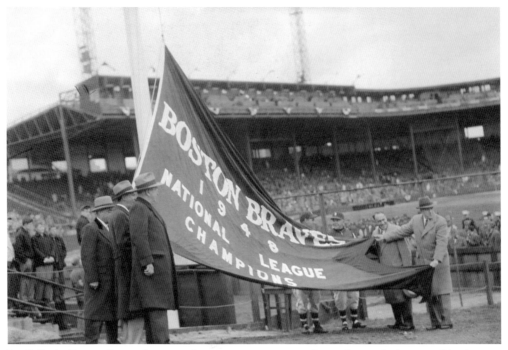

In 1948, the Boston Braves began a 15-year spring-training relationship with the city of Bradenton. The Braves finished in third place in 1947, their highest since 1916. In three decades, they had only six winning seasons, finishing in last place four times and in seventh place 11 times. Their new spring home set well with them, as they entered first place on June 11, 1948, and never relinquished the lead. Led by pitchers Johnny Sain and Warren Spahn and five regulars hitting over .300, the Braves raised their first pennant in 34 years (above). During the Braves tenure in Bradenton, Ninth Street Park came to be known as Braves Field after the Braves home in Boston (below). (Both courtesy of BPL.)

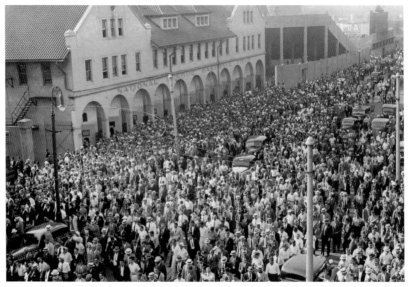

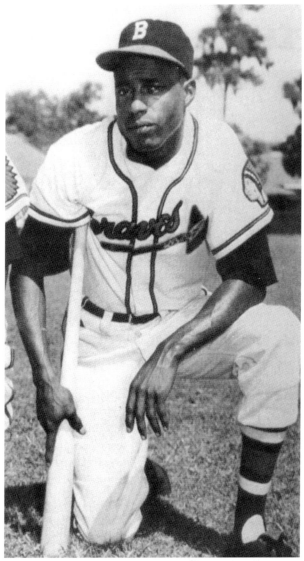

Sam "the Jet" Jethroe played with the Cleveland Buckeyes of the Negro Leagues from 1943 to 1948. He and Jackie Robinson tried out for the Red Sox in 1945, but neither made the team. Jethroe returned to Boston in 1950 as the Braves' first black player. The City of Bradenton granted "permission" for the Braves to integrate their playing field. This may well have saved a mass exodus of major-league teams from Florida, as they were certain to look for more accommodating venues in which to train their increasingly integrated ball clubs. Off the field, it was a different matter. While the Braves white players stayed at the Dixie Grande Hotel, the Braves arranged for Jethroe and the pioneering blacks that followed him—Hank Aaron among them—to stay in a rooming house owned by Lulu Mae Gibson in the "Colored" section of the city. Jethroe led the National League in stolen bases in 1950 and 1951. In 1950, the 32-year-old rookie was voted the National League Rookie of the Year, the oldest rookie in baseball history to win that honor. (Courtesy of theforgottenleagues.com.)

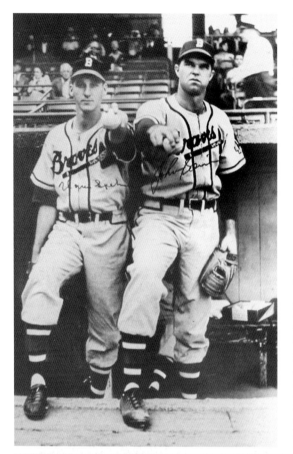

Warren Spahn (left) and Johnny Sain were rookies in 1942 and were mound mates until Sain was traded during the 1951 season. Both lost three years serving in World War II but still won 212 games in seven years. Each cracked 20 wins four times, giving birth to the adage, "Spahn and Sain and pray for rain." (Courtesy of REJMJ.)

The Braves and Bradenton inked a deal in 1952, with Braves general manager John Quinn (below, left), Bradenton mayor Sterling Hall (center), and Braves owner Lou Perini agreeing to five more years of Braves baseball in Bradenton. In 1954, the Boston Braves returned to their winter home as the Milwaukee Braves, having played their last year in Boston in 1953. (Courtesy of REJMJ.)

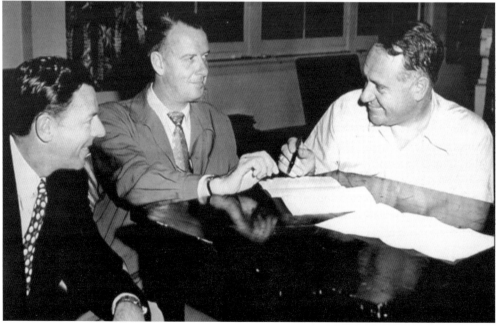

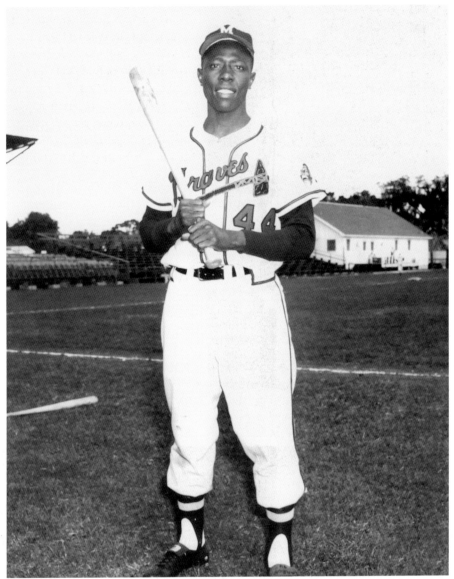

Henry Louis "Hammerin' Hank" Aaron joined the Braves in 1954, beginning his remarkable career. One of baseball's pioneering black players, he came to lead a determined, dignified battle against Florida's Jim Crow laws. A perfect model of consistent power, the 1957 MVP led the Braves to the world championship over the Yankees when he hit .393 with three home runs and seven RBIs in the seven-game series. He hit .333 in the 1958 World Series, but the Yankees got their revenge with a seven-game win over Aaron and his Braves. Always clutch, Hank hit .362 in 74 postseason plate appearances. The last player to play in both the Negro Leagues and the majors, the 21-time all-star endured death threats and made history in April 1974 when he hit career home run no. 715 in Atlanta's Fulton County Stadium, surpassing the great Babe Ruth. He finished with a record 755 career home runs and joined Ruth in Cooperstown in 1976. (Courtesy of REJMJ.)

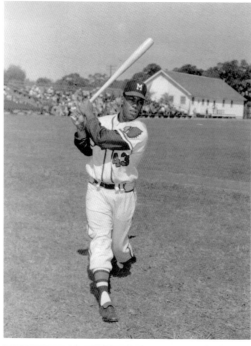

Wes Covington, striking a spring-training pose here in 1956, was a backup outfielder with the Braves from 1956 to 1961. A member of the National League champion Braves in both 1957 and 1958, he had the game-winning RBI in game two of the 1957 World Series at Yankee Stadium. (Courtesy of Atlanta Braves.)

Southpaw Bob Hartman hurls a pitch under the watchful eye of pitching coach Whitlow Wyatt on the first day of spring training in 1959. A highly touted prospect, Hartman was 20-10 for the Braves Double-A affiliate in Atlanta in 1958. He never quite made the transition to the major leagues; his career with the Braves totaled just one and two-thirds innings pitched. (Courtesy of REJMJ.)

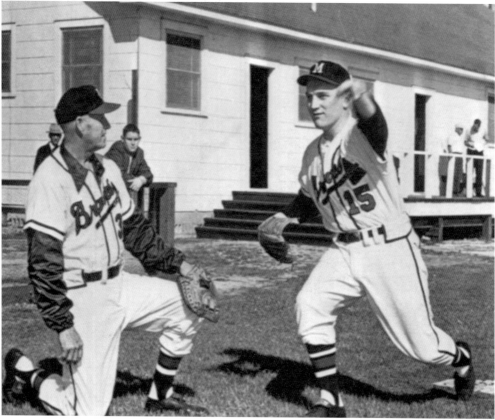

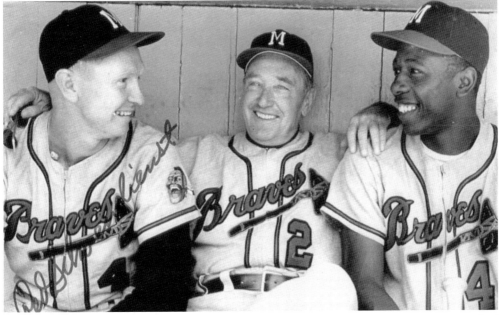

Manager Fred Haney (center) and Hank Aaron (right) are all smiles as they welcome Hall of Fame second baseman Red Schoendienst to spring training in 1958. Schoendienst was acquired in June 1957, stabilizing the infield and playing a significant role in the Braves pennant-winning seasons of 1957 and 1958. Schoendienst played 19 seasons before managing the Cardinals for 14 years, winning two pennants and one World Series. (Courtesy of REJMJ.)

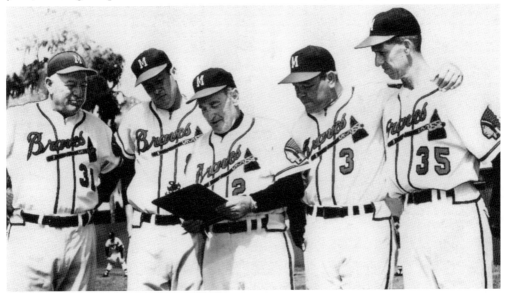

The Braves brain trust of 1957 gathers for a pre-workout meeting in Bradenton. From left to right are coaches Charlie Root (31), Connie Ryan, Fred Haney (2), Johnny Ripple (3), and Bob Keely (35). Their strategizing certainly paid off, as the Braves won the pennant and the World Series in 1957. (Courtesy of REJMJ.)

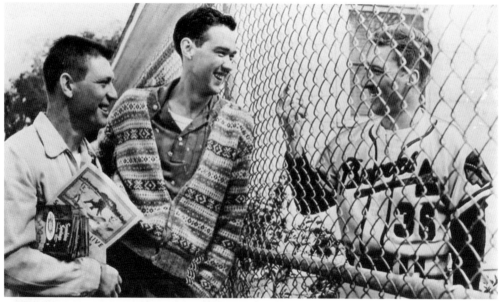

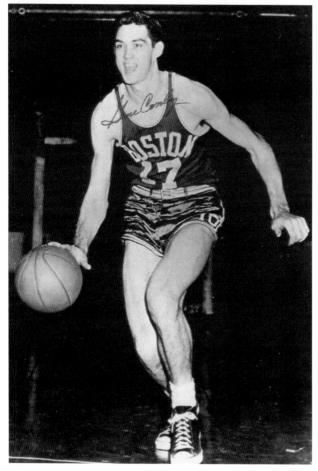

Above, Gene Conley (center) chats with teammate Lou Sleater and Red Sox infielder Billy Klaus outside the fence at Braves Field in February 1957. Conley pitched for the Braves for six seasons, including their pennant-winning seasons of 1957 and 1958. A member of the 1957 world champion Milwaukee Braves, the six-foot, eight-inch pitcher holds a unique place in American sports: he is the only man to win a world championship in both major-league baseball and in the NBA. Seen at left on the court, Conley was a member of the world champion Boston Celtics in 1959, 1960, and 1961. He actually played for two professional teams in the same city twice during his career: the Celtics and the Boston Braves in 1952 and the Celtics and the Boston Red Sox in 1961. (Both courtesy of REJMJ.)

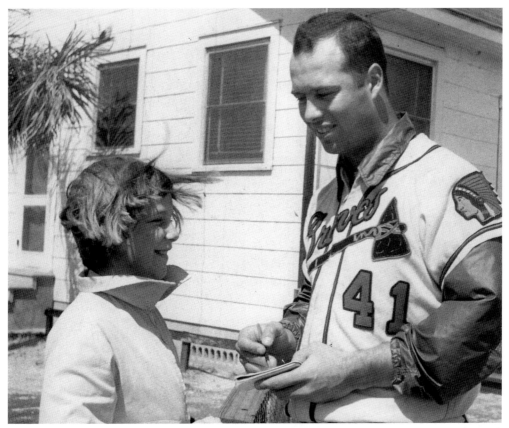

Milwaukee Braves superstar third baseman Eddie Mathews battles a spring Florida wind to sign an autograph for 10-year-old fan Nancy Staughton of Milwaukee outside the Bradenton clubhouse. The youngster ventured south with her family to catch some spring games in anticipation of the 1957 season. That year, Mathews was named to his third all-star team in a row and fourth in five years. (Courtesy of Harry Leder.)

Joe Torre (left) stretches during spring training in 1961. A rookie catcher that year, he went on to be a five-time all-star with the Braves before being traded to the Cardinals for Orlando Cepeda in 1969. He made four all-star teams with the Cards and was the 1971 National League MVP. Later in life, he became a legendary manager, leading the Yankees to six pennants and four World Series in 12 years. (Courtesy of Atlanta Braves.)

Below, manager Birdie Tebbetts (left) and pitcher Lew Burdette watch Warren Spahn work on his patented high leg kick in March 1962. The incomparable lefty was in the midst of six straight 20-win seasons and had led the National League in complete games for six years in a row as well. He and Burdette were teammates for 13 seasons, combining for 535 wins. They were also close friends and developed an affinity for the Bradenton area. Spahn purchased a cottage (above) on Anna Maria Island, just a few miles west of the ballpark on the Gulf of Mexico. The two spent many a happy hour there with their wives through 13 spring trainings. The Spahn family donated the home to Anna Maria Island with the hope of it becoming a museum. (Above, courtesy of Anna Maria Island Historical Society; below, REJMJ.)

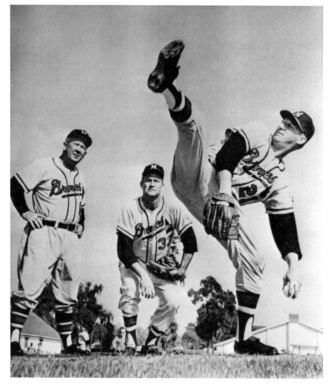

Birdie Tebbetts (right) was a major-league catcher from 1936 to 1952 with the Tigers, Red Sox, and Indians. He also managed for 11 years, including in 1961 and 1962 with the Braves. While training with them in Bradenton, Tebbetts fell in love with West Bradenton's island community of Holmes Beach, retiring there in 1992. A volunteer with the Anna Maria Island Little League, he said in an interview with the *Bradenton Herald* a month before his death in 1999, "I want to be remembered as a good father and a good citizen, but I am a baseball guy . . . that's all I ever wanted to be." He is buried in St. Bernard Catholic Church Memorial Garden (below) in Holmes Beach. (Right, courtesy of MCL; below, author's collection.)

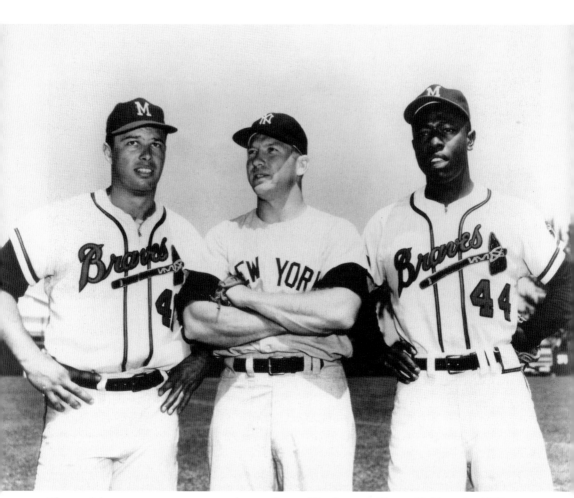

Three of the greatest stars to grace the confines of Bradenton's Braves Field in the 1950s were, from left to right, Eddie Mathews, Mickey Mantle, and Hank Aaron. Their teams were among baseball's elite. Hitting third and fourth in the Braves lineup, Aaron and Mathews homered in the same game a major-league record 75 times. Mantle was the game's signature player in the 1950s, leading the Yankees to eight pennants that decade. The Braves and Yankees met in the World Series in 1957 and 1958. Aaron hit a combined .364 in those two Fall Classics with three home runs and nine RBIs. Mathews hit a walk-off homer in the bottom of the 10th inning of game four of the 1957 Series, evening it at two games apiece. Mantle hit two home runs in game two of the 1958 Series. The Braves won in seven games in 1957, and the Yankees got revenge, also in seven games, in 1958. Aaron (755), Mantle (536), and Mathews (512) combined for 1,801 career homers. (Courtesy of REJMJ.)

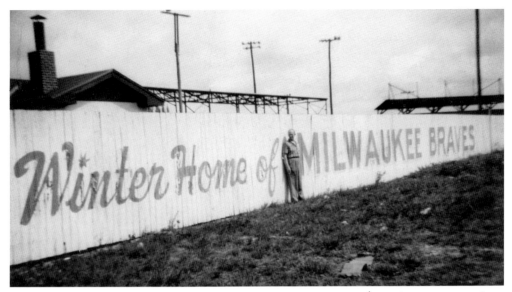

Above, longtime Braves supporter George Webb stands in front of the left-field fence at McKechnie Field in Bradenton around 1955. Behind the wall, the expansion of the Boys Club is taking place. The Boys and Girls Club has been there since 1946 and has had a long-standing relationship with the major-league teams that have trained there. Their relationship with the Pirates is now in its 44th year. Following the 1962 season, the Milwaukee Braves left Bradenton and established a new spring home in West Palm Beach. They spent 34 years there before moving to Orlando, where they remain today. Below, a disgruntled fan turned the McKechnie Field left-field wall into a graffiti statement of sorts upon learning that the Braves were moving out. (Above, courtesy of Atlanta Braves; below, National Baseball Hall of Fame.)

Warren Spahn takes a break from wind sprints in the outfield at Braves Field in Bradenton around 1960. One of the greatest pitchers in the history of the game, his 363 wins are the most by a left-handed pitcher in history. A World War II veteran who was wounded at the Battle of the Bulge, fought for the Remagen Bridge, and received a bronze star for bravery, Spahn lived on and invested in the Florida Gulf Coast community of Anna Maria Island. Buying land and building cottages on them, Spahn dubbed his properties with baseball monikers such as "Catcher's Mitt," "Home Plate," and "The Infield." His home was called "The Mound." The Hall of Fame pitcher and war hero continued to winter and develop his properties on Anna Maria Island up until his death in 2003; his son still owns two of the properties. Spahn, who had 13 seasons with 20 or more wins, was with the Braves through their entire tenure in Bradenton and left his mark both on and off the diamond. (Courtesy of REJMJ.)

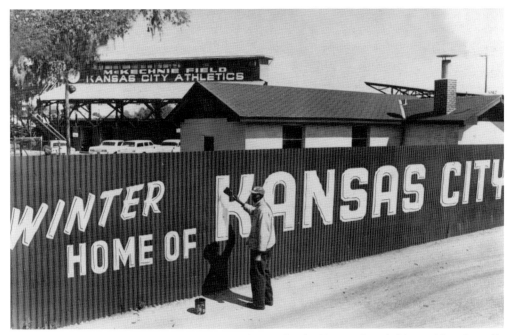

The spring of 1963 marked the first year in Bradenton for the Kansas City Athletics. Now formally known as McKechnie Field, the stadium hosted the A's for six springs. Here, employee Robert Brunner puts the finishing touches on the left-field fence before the A's arrival in February 1964. (Courtesy of National Baseball Hall of Fame.)

Spring 1964 brought the New York Mets, with three of baseball's all-time greats, to McKechnie Field. From left to right in New York uniforms, pitcher Warren Spahn, coach Yogi Berra, manager Casey Stengel chat with fans along with A's coaches (from left to right) Mel McGaha, Tom Ferrick, and Luke Appling (44). (Courtesy of MCL.)

McKechnie Field brought together two young Kansas City players who forged a relationship that would change the face of baseball. Tony La Russa (left) made his debut with the A's as a 17-year-old infielder in 1963. Dave Duncan (below) made his debut behind the plate a year later at age 18. Duncan was La Russa's pitching coach with the White Sox, A's, and Cardinals over a total of 28 years. In Oakland, they instituted the use of "closers," who specialized in coming in to pitch the ninth inning in save situations, which became an essential part of every pitching staff in baseball. In 1996, the two moved together to St. Louis, where they remained until after the 2011 season, when they both retired. Duncan was La Russa participated in six World Series together, winning three of them. (Left, courtesy of REJMJ; below, MCL.)

In the A's era, McKechnie Field was a launching pad for Hall of Fame careers. Reggie Jackson (right) became the A's right fielder in 1968. A lynchpin in their lineup for nine years, "Mr. October," began to emerge while still with the A's. He was injured for the 1972 World Series but hit a combined .302 with two homers and seven RBIs in the 1973 and 1974 Fall Classics and was the World Series MVP in 1973. Rollie Fingers (below) joined the A's pitching staff in 1968, and by 1972 he was a stalwart out of the bullpen. He had two saves in each of the 1972, 1973, and 1974 World Series. In those three series, he pitched 33 1/3 innings, compiling a 2-2 record and a 1.35 ERA. Fingers was inducted into Cooperstown in 1993, with Jackson joining him the following year. (Right, courtesy of National Baseball Hall of Fame; below, REJMJ.)

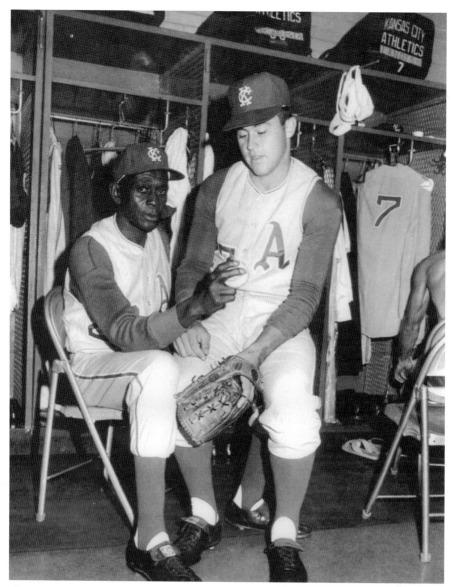

This photograph tells the story of the kid and the sage, as Jim "Catfish" Hunter sits on the lap of the venerable Satchel Paige in 1965. Catfish, who began his trek to the Hall of Fame at McKechnie Field, made his major-league debut in June 1965 at the age of 19. Later that year, A's owner Charlie Finley signed Paige, the 58-year-old former Negro League star, to pitch one game. Paige, who joined the major leagues in 1948 at the age of 41, pitched three innings against the Red Sox, facing 10 batters, giving up one hit and no walks with a strikeout. Hunter pitched for the A's for 10 years, cracking the 20-win mark in four consecutive seasons, from 1971 through 1974. He won the American League Cy Young Award in 1974, when he went 25-12 and led the league with a 2.49 ERA. He was 4-0 in three World Series games with the A's, with a 2.19 ERA in 37 innings pitched. Leroy Robert "Satchel" Paige was inducted into the Hall of Fame in 1971; James Augustus "Catfish" Hunter joined him in 1987. (Courtesy of REJMJ.)

Golf and spring training have always gone hand in hand. Here, Kansas City A's first baseman Ken "Hawk" Harrelson holds the G. Taylor Spink Trophy, which crowned him the winner of the National Baseball Players Golf Tournament in February 1965. Hawk played nine years, retiring at 29 to give golf a go. He played in the 1972 British Open and has been the voice of the White Sox since 1990. (Courtesy of Miami-Metro News Bureau.)

PITTSBURGH

PIRATES

1969

SPRING
TRAINING
ROSTER

Press, Radio,
TV Guide

1969 is the
100th Anniversary
of Professional
Baseball

JUNE 30, 1969 . . . FORBES FIELD'S
60th (and probably last) BIRTHDAY

The first time the Pittsburgh Pirates trained in Florida was in Jacksonville in 1918. They tried Miami Beach in 1947 and Fort Pierce in 1954 before making Terry Park in Fort Myers their winter home from 1955 to 1968. In 1969, they arrived in Bradenton, where they have been ever since. This program is from their first spring at McKechnie Field. (Author's collection.)

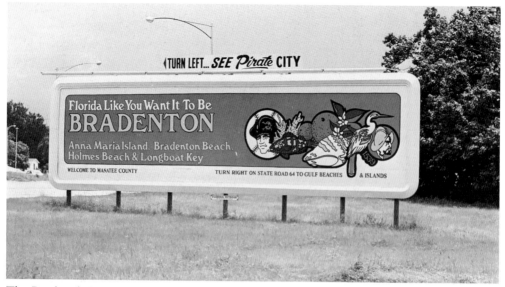

The Pittsburgh Pirates arrival at McKechnie Field in Bradenton in the spring of 1969 began a relationship with the community that entered its 44th year in the spring of 2013. This billboard indicates the value the city of Bradenton places upon their Pirates, considering them among their natural resources. (Courtesy of MCL.)

In 1960, Bill Mazeroski hit one of the most legendary home runs in baseball history with his game seven walk-off shot that catapulted the Pirates to the world championship over the Yankees. "Maz" played 17 years (1956–1972) with the Pirates and is widely recognized as one of the best defensive second basemen of all time. He spent his last four springs at McKechnie Field and was inducted into Cooperstown in 2001. (Courtesy of REJMJ.)

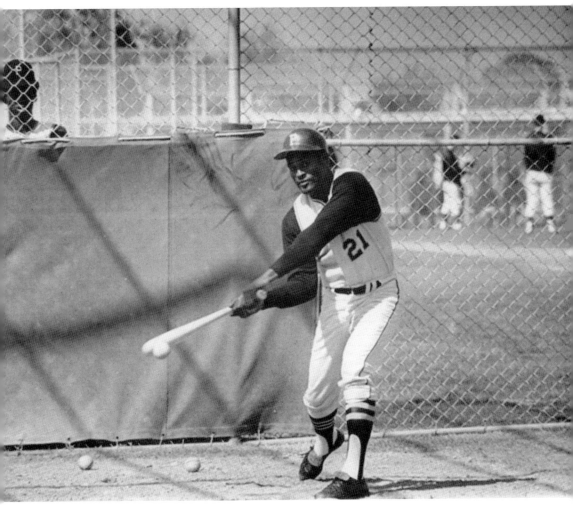

Roberto Walker Clemente, the "Great One," transcended the diamond; his life took on a measure of social significance far beyond the game of baseball. He played the game with a controlled reckless abandon, if there is such a thing, and he lived his life the same way, especially when it came to humanitarian causes. A 12-time all-star and Gold Glove winner and the 1966 MVP, he was also the MVP of the 1971 World Series, leading the Pirates to an upset victory over the Baltimore Orioles. His passion for his fellow man cost him his life. Following an earthquake in Nicaragua in late 1972, Clemente engineered a relief effort, and after he learned that the supplies he sent were stolen, he organized another, this time going with the supplies to make sure they got to the people they were intended for. His plane never reached its destination, and Clemente's body was never recovered. The Hall of Fame waved their retirement requirement and inducted Roberto Clemente in July 1973, making him the first Latin player so honored. (Courtesy of REJMJ.)

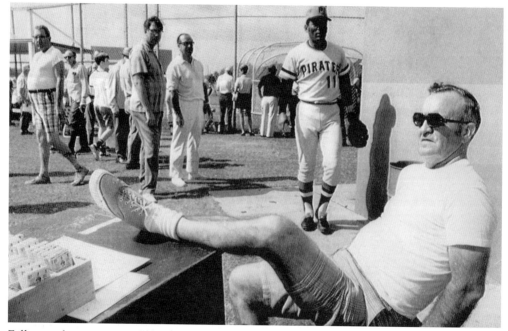

Following his nine-year playing career, Danny Murtaugh managed the Pirates for 15 years. He retired following the Pirates World Series victory in 1971 and came to spring training in 1972 to help take tickets and relax. He returned in 1973 and managed four more years. In his 15 years at the helm, the Pirates were 1,115-950, winning two pennants and two World Series. His no. 40 was retired in 1977. (Courtesy of REJMJ.)

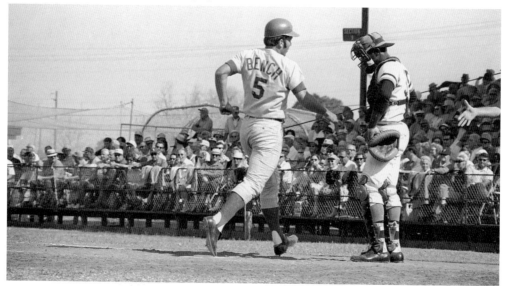

Manny Sanguillen, seen here watching Reds catcher Johnny Bench cross home after a home run at McKechnie Field around 1970, caught for the Pirates for 12 years. An all-star in 1971 and 1972, the likeable "Sangy" volunteered to replace the irreplaceable right fielder Roberto Clemente. An outstanding clutch performer, Sanguillen hit .379 in the 1971 World Series. (Courtesy of MCL.)

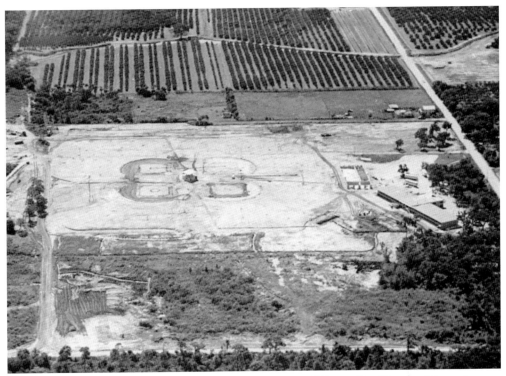

The arrival of the Pirates coincided with the construction of "Pirate City." Located five miles east of McKechnie Field, the Pirates actually train in this facility, which is equipped with housing. The coziness of the four fields provides a unique opportunity for fans to rub elbows with the players. (Courtesy of MCL.)

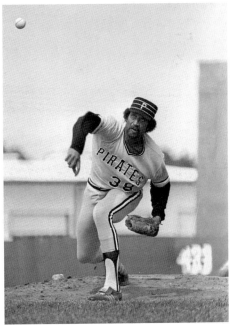

Jim Bibby, seen here unleashing a 1978 spring-training offering at McKechnie Field, pitched for five years with the Pirates. A Vietnam combat veteran, Bibby hurled a no-hitter with Texas in 1973. An integral part of the 1979 world champion Pirates, he tossed 17 1/3 postseason innings, with no decisions but a combined ERA of 2.08 and 10 strikeouts in 10 innings of World Series relief. (Courtesy of MCL.)

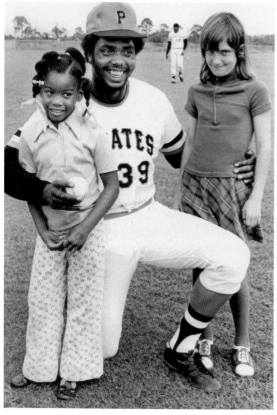

The Pirates have had a long-standing relationship with the Bradenton Boys and Girls Club, which is just beyond the left-field fence at McKechnie Field. At left, Dave Parker poses with two somewhat shy members in 1974. Below, young Aaron Ackerman shakes hands with Willie "Pops" Stargell and presents him with a plaque honoring his support of what was then simply known as the Boys Club. This was part of the 1977 opening-day ceremonies of the Boys Club baseball season. "Pops" spoke to the boys about learning good character through participation in sports. (Left, courtesy of MCL; below, Jeff Bachrach.)

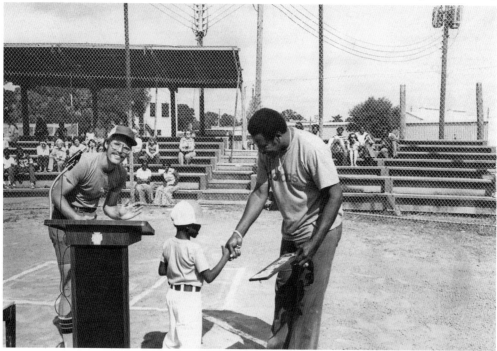

Pirates lefty Jim Rooker hurls a pitch during an intra-squad game at Pirate City in 1977. Rooker and his beard were always ready to take part in Bradenton's annual DeSoto Parade. He won 82 games in eight years with the Pirates and pitched 8 2/3 innings in the 1979 World Series, surrendering only one run and five hits. (Courtesy of REJMJ.)

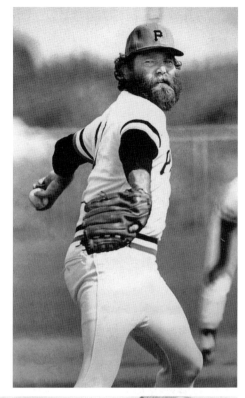

In a lighthearted moment in 1984's spring training, Pirates catcher Tony Peña is grabbed by pitcher Cecilio Guante while José DeLeón (left) and Andy Rincon join in the fun. Peña caught for 18 years in the big leagues, seven of them with the Pirates, and was a Pirate all-star four times. He is now a bench coach for the New York Yankees. (Courtesy of George Gojkovich.)

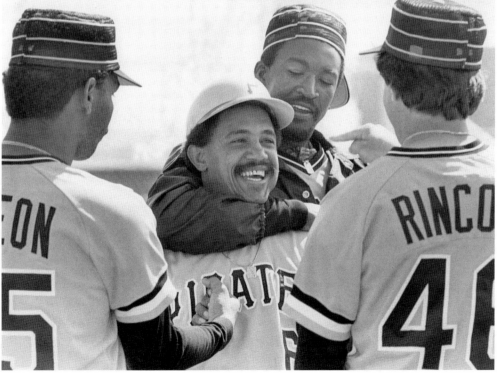

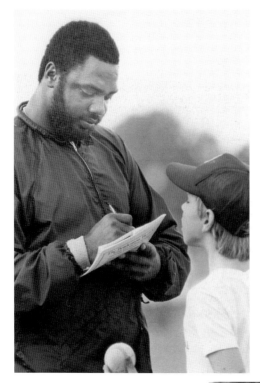

A Pirates 14th-round draft pick out of high school in 1970, Dave Parker played 11 of his 19 big-league seasons in Pittsburgh. Nicknamed "the Cobra," Parker was one of the National League's best players from 1975 to 1982. Parker, a five-time all-star with the Pirates, was always sought after by photographers and fans. Here, he obliges a young fan with his autograph around 1980. (Courtesy of Ed Malliard.)

Randy Tomlin delivers a pitch at McKechnie Field with the Boys and Girls Club looming over his shoulder around 1990. Tomlin is credited with the "Vulcan Change," which is thrown with the ball held between the middle and ring finger. He coached at his alma mater, Liberty University, and in the Washington Nationals system for five years before becoming the head coach at Liberty Christian Academy in Lynchburg, Virginia. (Courtesy of Janice Johnson.)

Kent Tekulve runs wind sprints in the McKechnie Field outfield in 1978. A Pirate bullpen stalwart for 12 seasons, his best year was 1979, when he went 10-8 with a 2.75 ERA and 31 saves. He also had three saves in the 1979 World Series, including games six and seven. His 158 career saves ranks him second all-time for the Pirates behind Elroy Face. (Courtesy of National Baseball Hall of Fame, Alex Traube Collection.)

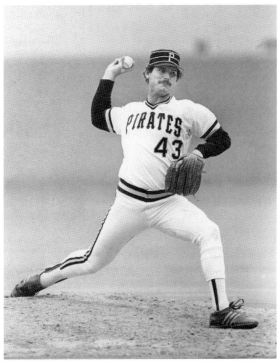

As a rookie in 1978, Don "Caveman" Robinson was the best pitcher on the Pirates staff, going 14-6 with a 3.47 ERA. "Caveman" won the second game of the 1979 World Series and pitched for the Pirates for 10 years. A very good hitting pitcher, he won the Silver Slugger Award three times as the league's best hitting pitcher. When he retired, Robinson settled in Bradenton, where he coached and sponsored youth baseball teams. (Courtesy of REJMJ.)

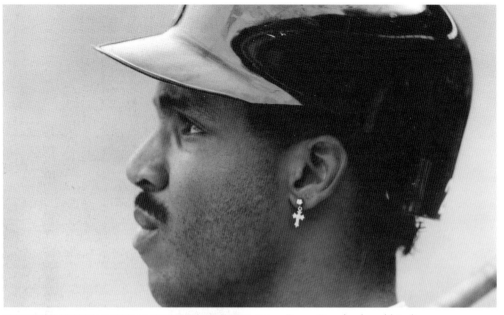

Barry Bonds played his first seven years with the Pittsburgh Pirates, winning two National League MVP Awards in 1990 and 1992. In his 20 postseason games with Pittsburgh, Bonds hit .157 with one home run and three RBIs. A centerpiece of baseball's steroid controversy, in 2013 Bonds received only 36.2 percent of the required 75 percent required for induction to the National Hall of Fame, his first time on the ballot. This has some pundits thinking he may never get in. (Courtesy of Louis DeLuca.)

Kirk Gibson, seen here as a Pirate at McKechnie Field in 1992, was a member of the 1984 world champion Tigers and the 1988 National League MVP. In 1988, when he was injured, his one at-bat in the World Series resulted in a pinch-hit walk-off homer off Dennis Eckersley. Gibson dragged his wounded leg around the bases, pumping his fist in what has become one of baseball's iconic moments. (Courtesy of Stu Kreisman.)

The best player on the 2013 Pittsburgh Pirates, Andrew McCutchen is in his fifth year with the team. Seen here in the batter's box at McKechnie Field in 2011, the 25-year-old two-time all-star had a breakout year in 2012, hitting .327 with 31 home runs and 96 RBIs, leading the Pirates to their best season since 1997. (Courtesy of Jamie Wisner.)

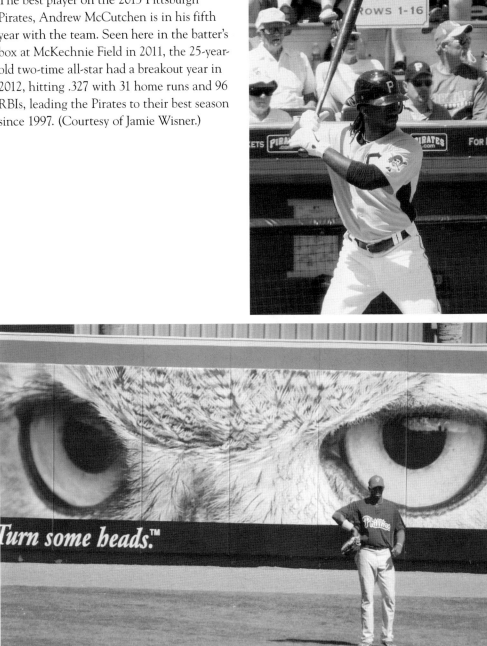

The watchful eyes of the McKechnie Field owl keep Philadelphia Phillies outfielder Domonic Brown in its sights during a spring-training contest in March 2011. The Phillies, who trained at this field from 1925 to 1927, and the Pirates have the longest-running spring-training affiliations in the National League. The Phillies have been training in Clearwater, Florida, since 1947, and the Pirates have been at McKechnie Field since 1969. (Courtesy of Martha Martin.)

Jim Leyland managed the Pirates for 11 seasons and was twice named manager of the year. He led them to three straight postseason appearances in 1990, 1991, and 1992. Leyland has managed the Marlins, Rockies, and Tigers but maintains a home in Pittsburgh, where he met his wife and raised his family. In Bradenton, he began each day with breakfast at Popi's Restaurant next to McKechnie Field. (Courtesy of REJMJ.)

Bobby Bonilla played six seasons with the Pirates, from 1986 through 1991, making the all-star team in four of those seasons. He was a key player on three postseason Pirates teams. His best year was 1991, when he hit .280 with 32 home runs and 120 RBIs, finishing second in the MVP voting to teammate Barry Bonds. Bonilla still lives in the Bradenton area. (Courtesy of REJMJ.)

Wilver Dornell "Pops" Stargell is one Pittsburgh's most beloved Pirates. Seeing baseball as "a way out of the ghetto," he signed with the Pirates in 1958 and never looked back. He became a prolific power hitter in the 1970s, finishing in the top three in MVP voting three times. A man of Herculean strength, his prodigious home runs became legendary. In the 61 years of Forbes Field, a ball cleared the right field roof only 18 times—Stargell hit seven of them. He often spoke of his responsibility to the kids of Pittsburgh: "I think the black ballplayer should be responsible to the black community. The people, in many ways, helped put him where he is. He should be visible to the kids in the ghetto." And he always walked the walk. Acquiring the nickname "Pops" as the team's elder statesman, he won the 1979 MVP award at the age of 39 and was MVP of the 1979 World Series as well. His 475 career homers tops the Pirates list, and he was inducted into Cooperstown in 1988. (Courtesy of Jeff Lynch.)

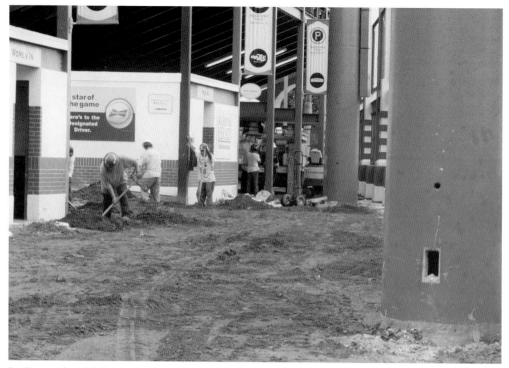

In September 2012, renovations began anew at McKechnie Field. Above, construction crews are hard at work at the third-base concession stands under the grandstand. The proposed $7.5 million plan is to include a fan-accessible area beyond the outfield wall with a passage from left field to right field (below), covered outfield bleachers with seats that have back supports, a center-field tiki hut or specialty bar, new seating from the first-base side to the third-base side, relocated bullpens—moving from the playing field to beyond the outfield walls in left and right field—changes to the concession area, and upgrades to the restrooms. In addition, the scoreboard will become part of the left-field wall as it is at Fenway Park. (Both author's collection.)

PAYNE PARK

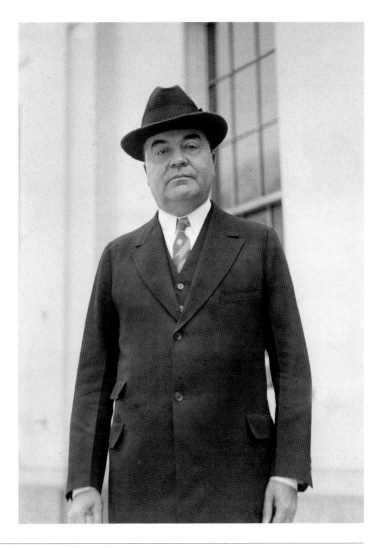

Circus magnate John Ringling was the man who put in motion the notion that the New York Giants come to Sarasota to train. Ever mindful of a business opportunity, Ringling knew manager John McGraw and his Giants coming to Sarasota would garner interest from other Northeastern cities, especially New York. (Courtesy of Library of Congress.)

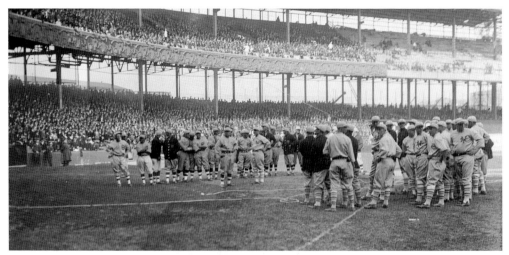

When the New York Giants arrived at Payne Park in 1924, they were the reigning National League champs. They had won eight pennants in 14 years and were in the midst of what would be four straight National League championships from 1921 to 1924. They won the World Series in 1921 and 1922. (Courtesy of REJMJ.)

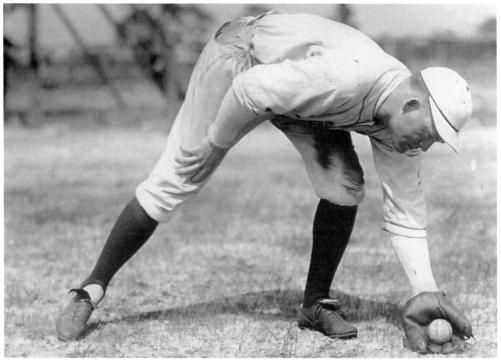

St. Louis Cardinal second baseman Rogers Hornsby fields a ball at Payne Park in March 1924. The Cardinals, who were training in Bradenton, traveled to Sarasota to tangle with the New York Giants. Hornsby's lifetime batting average of .359 is second all-time behind Ty Cobb. Twice an MVP and twice a Triple Crown winner, Hornsby is considered by many to be the greatest second baseman of all time. (Courtesy of REJMJ.)

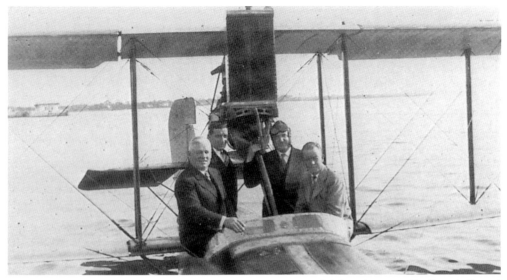

John McGraw's 1924 Giants were arguably the most successful franchise in all of baseball, and he was among the game's biggest names. McGraw, seated here on the left, invested in Sarasota real estate. He is about to take a flight around Sarasota Bay to have a bird's-eye look at his land holdings. (Courtesy of Sarasota County History Center.)

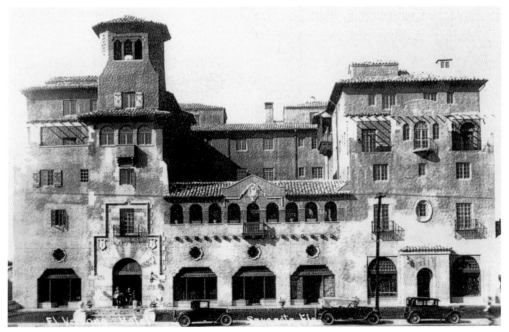

The El Verona, built by Owen Burns and named in honor of his wife, opened in 1926 and hosted many a big-league ballplayer through the years of spring training in Sarasota. Eventually purchased by John Ringling in 1930, it became known as the Ringling Towers. It was vacated in the early 1980s and demolished in 1998. (Courtesy of State Archives of Florida, *Florida Memory*.)

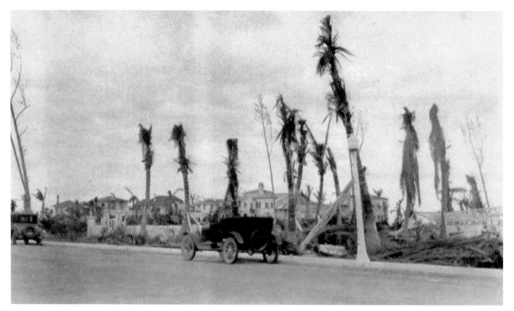

The Great Miami Hurricane of September 1926 slammed into Miami with 125-mile-per-hour winds and then hit Pensacola and the Florida Panhandle a few days later. The category-four storm effectively put an end to Florida's land boom and ushered the Great Depression into Florida earlier than in the rest of the country. It chased the Giants out of Sarasota; no big-league team returned until 1933. (Author's collection.)

The Hurricane of 1926 set back Florida spring training and also gave birth to another sports tradition. The University of Miami, founded in 1925, took on the nickname "Hurricanes" in memory of the storm. They also adapted the ibis as their mascot, as legend has it the ibis is the last bird to leave before a hurricane strikes and the first to return when it is gone. (Author's collection.)

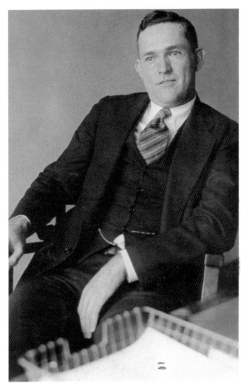

Following the 1926 season, when the Cardinals won their first-ever World Series, Rogers Hornsby and Cardinals owner Sam Breadon engaged in a contract dispute that ended in Hornsby being traded to the New York Giants. The trade brought together two of the biggest names in baseball, Hornsby (right) and Giants manager John McGraw. Hornsby takes his cuts in the Payne Park batter's box (below) in the only spring training he would enjoy with the Giants—before the 1928 season began, he was traded to the Braves. (Both courtesy of REJMJ.)

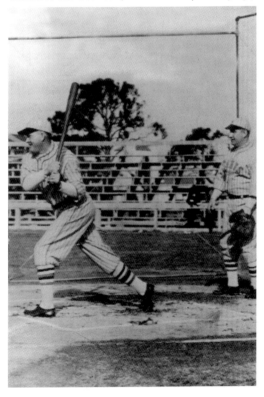

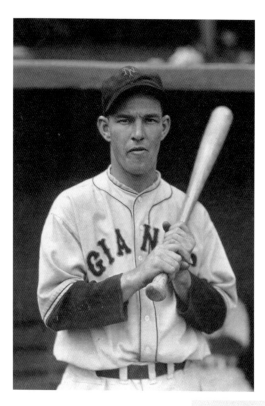

In the spring of 1926, a 17-year-old kid named Mel Ott was at Payne Park. He made the squad and embarked on a 22-year career, all with the Giants. He would become the youngest player to hit 100 career home runs, the first National League player to crack the 500-home-run mark, and an 11-time all-star. He was inducted into Cooperstown in 1947. (Courtesy of REJMJ.)

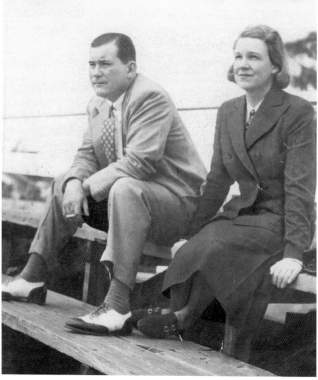

Tom Yawkey and his first wife, Elise, seen here in the stands at Payne Park in 1938, purchased the Red Sox in 1933 and immediately entered into an agreement to bring them to Sarasota for spring training. The Red Sox had fallen on hard times, but Yawkey set out to return the team to the greatness it had known in the 1910s, acquiring some of the biggest names in the game. (Courtesy of REJMJ.)

Yawkey's first bold move was to acquire Philadelphia Athletics southpaw Robert "Lefty" Grove, seen here at Payne Park around 1935. The six-player trade included $125,000 of Yawkey's money, which he was more than willing to spend. Grove was the American League MVP in 1931, going 31-4 and leading the A's to their third straight pennant. Grove won 105 games for Boston, including his 300th, in 1941. (Courtesy of REJMJ.)

In 1935, Yawkey procured shortstop and manager Joe Cronin from the Senators for journeyman Lyn Lary and $225,000. Cronin is seen here with his kids in the stands at spring training. He was the Red Sox general manager and went on to become the president of the American League. Inducted into the Hall of Fame in 1956, his no. 4 was retired by the Red Sox. (Courtesy of BPL.)

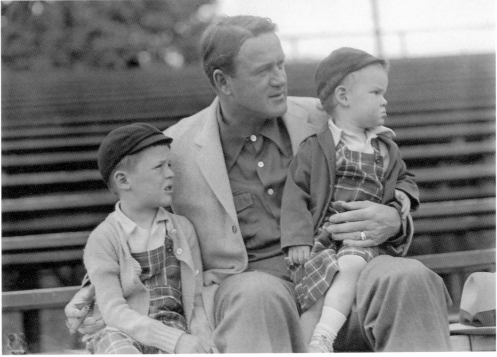

Two other Hall of Famers, Heinie Manush (left) and Eddie Collins, seen here in the stands at Payne Park in the spring of 1936, were part of the Red Sox 1930s story. Collins, a boyhood classmate of Yawkey's, was named their general manager, and Manush, at the end of a Hall of Fame career, was acquired for the 1936 season. Manush only played for Boston in 1936, but Collins served 14 years as Yawkey's general manager. (Courtesy of REJMJ.)

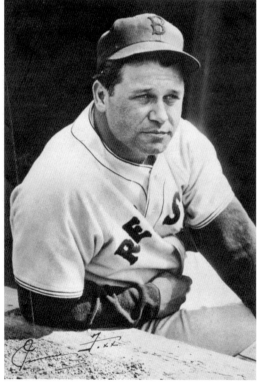

In December 1935, Yawkey sent two prospects and $150,000 to Philadelphia for Jimmie Foxx. Known as "The Beast," Foxx is seen here pausing before a game in 1938. He was the game's most prolific home-run hitter at the time and was the 1938 MVP, hitting .349 with 50 homers and 175 RBIs, still a team record. He was the second man to reach 500 career home runs and was enshrined in Cooperstown in 1951. (Courtesy of REJMJ.)

Bobby Doer was welcomed to spring training at Payne Park and to the Red Sox in 1937. The quiet Californian was the first of Tom Yawkey's homegrown products to make it to the Hall of Fame. A nine-time all-star at second base, he was considered the "unofficial captain" of the 1946 pennant-winning team and was the first-base coach of the Red Sox "Impossible Dream" American League championship team of 1967. (Courtesy of SCHC.)

Ted Williams, another homegrown product from the West Coast, showed up at Payne Park in 1939 from the San Diego Padres of the Pacific Coast League. Here, Williams takes a few cuts in the cage at Payne Park around 1940. He told people that his goal was to become "the greatest hitter who ever lived." Many believe he accomplished this goal. (Courtesy of SCHC.)

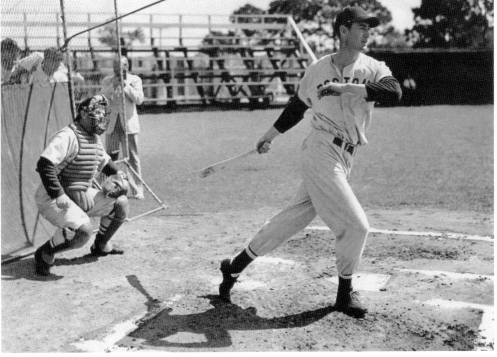

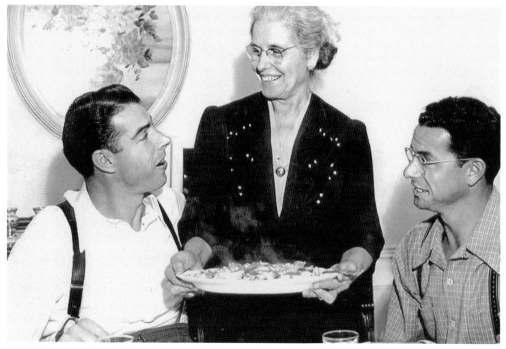

In 1940, yet another Californian made his way to Payne Park: 23-year-old Dom DiMaggio (right). His older brother Joe (left) had been playing for the Yankees since 1936. Dom, the "Little Professor," played center field for the Red Sox for 11 years and was an all-star seven times. Here, their mother, Rosalia, serves her boys a home-cooked meal before they leave for spring training. (REJMJ.)

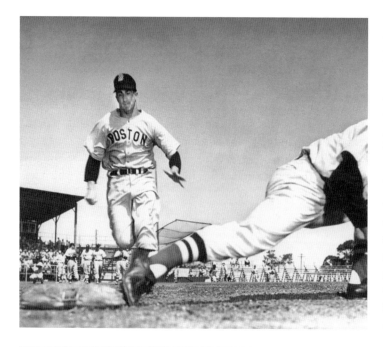

Johnny Pesky, seen here sprinting down the first-base line at Payne Park, arrived in 1942, putting what were known as "The Teammates" in place. The shortstop became the first player in history to lead his league in hits in his first three years. Also known as "Mr. Red Sox," Pesky spent 61 years with the organization. He passed away in August 2012 as the most beloved Red Sox player of all-time. (Author's collection.)

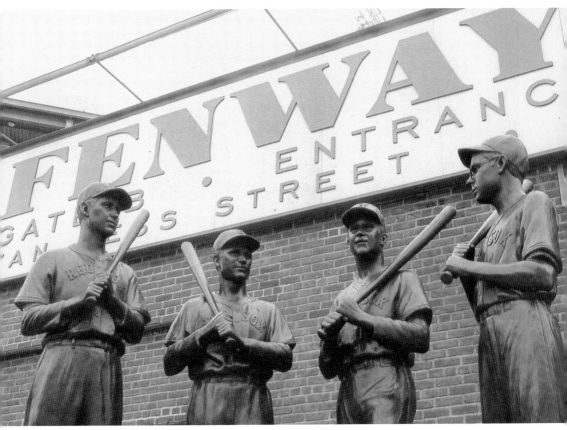

Friendships forged on the spring-training fields of Payne Park in Sarasota ended in bronze outside of Fenway Park's Gate C on Van Ness Street in Boston. From left to right, Ted Williams (1939–1960), Bobby Doerr (1937–1951), Johnny Pesky (1942–1952), and Dom DiMaggio (1940–1953) were teammates for 10 years. They collectively played 54 years in a Red Sox uniform, were chosen for 34 all-star teams, missed 14 years to World War II and Korea, and remained lifelong friends. The concept of "The Teammates" was born in October 2001, when Johnny Pesky and Dom DiMaggio took a drive from Boston to Florida to visit a dying Ted Williams. Doerr was unable to make the trip because he was tending to his wife of 63 years, Monica, who had recently suffered a stroke. The drive, the visit, and their friendship were chronicled in the book *The Teammates* by David Halberstam. Following Williams's passing in 2002 and DiMaggio's in 2009, the Red Sox memorialized their friendship and their place in Red Sox history with this statue, which was dedicated in 2010. (Author's collection.)

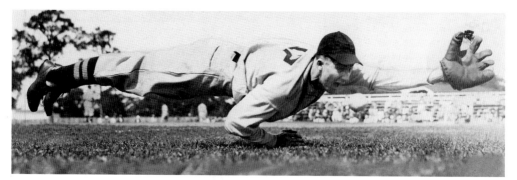

Robert Daughters's major-league career began on April 24, 1937, and ended that same day. Seen here at Payne Park in spring training in 1937, the year he made the squad, Daughters ran for catcher Rick Ferrell and scored a run in the Red Sox's second game of the season at Fenway Park. He played three more years in the minors, where he got a hit off of Satchel Paige, but never made it into another big-league game. (Courtesy of REJMJ.)

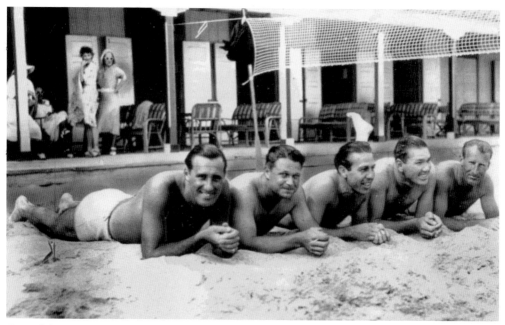

One of the perks of Florida spring training is the sun and the sand. These stars gather early in the day on Miami Beach before they head to their respective camps. Seen here are, from left to right, Hank Greenberg (Tigers), Jimmie Foxx (Red Sox), Lyn Lary (Indians), Dizzy Dean (Cardinals), and "Goose" Goslin (Tigers). Greenberg, Goslin, and Lary trained in Lakeland, Dean trained in Daytona Beach, and Foxx trained in Sarasota. (Courtesy of REJMJ.)

Golf, another perk, has been a spring-training staple for players since it began. It was no different for Babe Ruth. Here, Ruth, a scratch golfer, blasts a ball down a Florida fairway. While barnstorming in California during his nascent days with the Red Sox, he was known to play 54 holes a day. (Author's collection.)

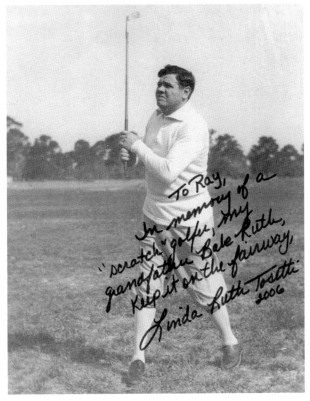

To Ray,
In memory of a
"scratch" golfer, my
grandfather Babe Ruth,
Keep it on the fairway,
Linda Ruth Tosetti
2006

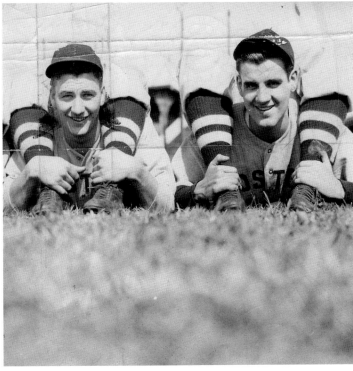

Red Sox teammates Woody Rich (left) and Frank Dasso have a little spring-training fun at Payne Park with a pair of unidentified ankles around 1940. Rich pitched a total of 28 games with the Red Sox from 1939 to 1941, while Dasso, a Red Sox farmhand for six years, finally made it to the big leagues in 1945 with the Reds, pitching in 18 games. (Courtesy of REJMJ.)

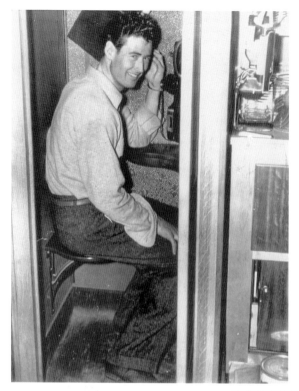

Ted Williams makes a call declaring he has arrived safely in Sarasota for 1940 spring training. Known as "The Kid," it was Williams's third spring training with the Red Sox following his spectacular rookie season in 1939, in which he hit .327 with 31 home runs and 145 RBIs. The RBI mark remains a record for rookies. (Courtesy of REJMJ.)

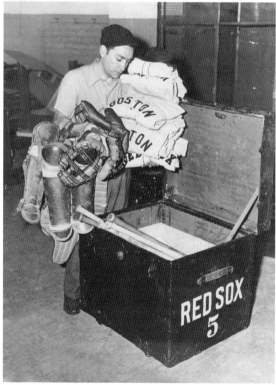

Red Sox clubhouse boy Johnny Orlando unpacks a trunk in the Red Sox clubhouse at Payne Park in 1940. Orlando is the man who nicknamed Ted Williams "The Kid." Williams was late for his first spring training in 1938 due to a flood in California, and when he arrived Orlando quipped, "The kid is here." The name stuck with Williams his entire life, and the two became lifelong friends. (Courtesy of REJMJ.)

PAYNE PARK

World War II curtailed travel for spring training, so the Red Sox were forced to stay home. Along with the rest of Florida, Sarasota was blacked out of major-league baseball until the end of the war. The Red Sox chose Tufts University, seen here in 1943, in nearby Medford, Massachusetts, as their spring-training site. (Courtesy of REJMJ.)

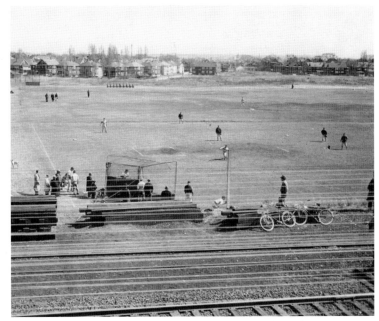

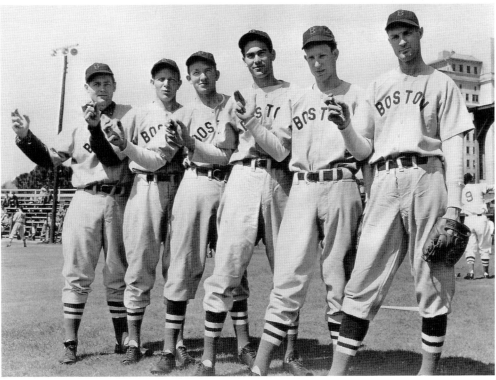

Manager Joe Cronin's right-handers were ready to go at Payne Park in the spring of 1941. From left to right they are Emerson Dickman, Dick Newsome, Mike Ryba, Tex Hughson, Woody Rich, and Joe Dobson. In the far right background, behind Dobson's glove, Ted Williams (9) stands with a bat in his hands. (Courtesy of Boston Red Sox.)

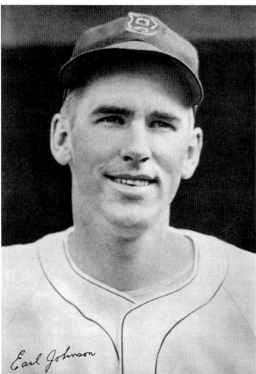

"Fordham" Johnny Murphy (38) warms up on the Payne Park sidelines in March 1947. Murphy pitched for 12 years with the Yankees and ended his career with the Red Sox, throwing 54 innings of relief for them in 1947. In six World Series with the Yankees, he threw 16 1/3 innings and was 2-0 with a 1.10 ERA. (Courtesy of SCHC.)

Earl "Lefty" Johnson, seen here in the Payne Park dugout, pitched seven years with the Red Sox, from 1940 to 1950. Missing three years to World War II, Johnson came ashore in Normandy on D-Day plus-five and fought at St. Lo, France, where he received a bronze star, and again at the Battle of the Bulge, where he received the silver star for bravery. (Author's collection.)

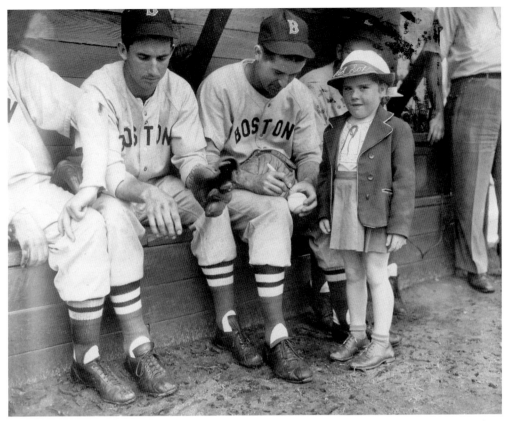

Red Sox pitcher Tommy Fine signs a baseball in the Red Sox dugout at Payne Park for five-year-old Sandra Tehr, whose eyes are glued on the camera. Sitting to the left of Fine is Red Sox backup third baseman Merle Combs. Fine pitched only one year for Boston, in 1947, while Combs played five years in the majors, three of them with Boston. (Courtesy of REJMJ.)

Red Sox manager Joe McCarthy (right) surveys the Payne Park playing field in March 1948 with Tom Rand. McCarthy, who had managed the Yankees for 16 years, was in his first year with Boston. The Hall of Fame manager was the skipper of the Red Sox for the 1948 and 1949 seasons and was let go 59 games into the 1950 campaign. (Courtesy of Clarence Lucia.)

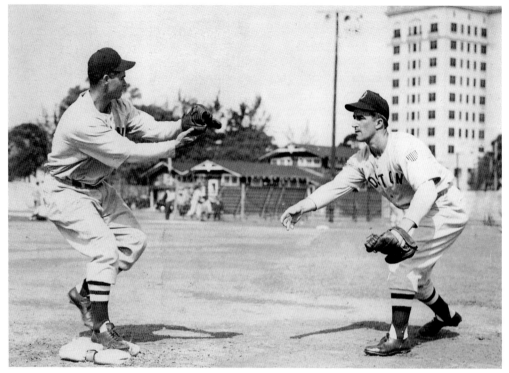

Above, Johnny Pesky and Bobby Doerr work on their double-play feeds at Payne Park in spring training 1942. They were teammates for seven years. Doerr was elected into the Hall of Fame by the Veterans Committee in 1988, and his no. 1 jersey is retired and displayed on the right-field facade at Fenway Park. In 2008, Johnny Pesky's no. 6 six joined his teammate on the fabled facade. For Fenway Park's 100th birthday game on April 20, 2012, Pesky and Doerr were the last two players brought on the field (below). Pesky (left) was wheeled out by Jason Varitek, while Doerr was escorted by Tim Wakefield with David Ortiz between them. Pesky passed away in August 2012, leaving Doerr as the oldest living Red Sox player. (Above, courtesy of REJMJ; below, Lynda Fitzgerald.)

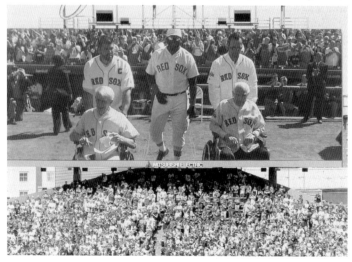

Mel Parnell and his wife, Velma, are all packed as they head for Sarasota and spring training in 1948. Parnell is one of the best left-handed pitchers in Red Sox history. He was 125-73 in 10 years with the Red Sox, and his 25 wins in 1949 are the most by any Sox southpaw. Parnell, who pitched a no-hitter in 1956, was the Red Sox television color man in the 1960s. (Courtesy of REJMJ.)

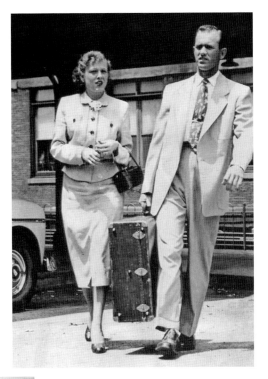

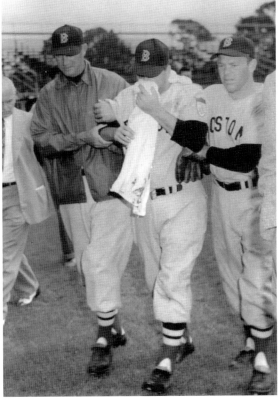

In spring training in 1952, player-manager Lou Boudreau was knocked unconscious by a foul tip from the bat of catcher Gus Niarhos. Boudreau was leaning too close to the screen behind the batting cage when the ball struck him in the nose, breaking it, bruising his jaw, and knocking him out. Here, he is being escorted to the clubhouse by coach Paul Schreiber (left) and Vern Stephens. (Courtesy of REJMJ.)

Jimmy Piersall made his major-league debut with the Red Sox in 1950 at the age of 20. He spent eight spring trainings with the Red Sox at Payne Park and was an all-star twice. At left, he takes a swing near the equipment shed at Payne Park during spring training in 1953. Piersall was returning after missing the last seven weeks of the 1952 season, when he was hospitalized at Westborough State Hospital in Westborough, Massachusetts, for "nervous exhaustion." His battle with bipolar disorder was unveiled in an autobiographical book, *Fear Strikes Out*, which was made into a movie of the same name in 1957, starring Anthony Perkins and Karl Malden. Below, he boards a plane bound for Sarasota in the nascent days of airline travel for baseball teams. (Left, courtesy of REJMJ; below, Edwin Stephens.)

Fear Strikes Out was written by noted sportswriter Al Hirschberg and published in 1955. It was a groundbreaking look at the controversial subject of mental illness. Hollywood, responding to the book's success, turned it into a movie and a stage play and brought it both to the big screen and to television. In the play, broadcast live on the CBS show *Climax*, Tab Hunter played Piersall, while *Psycho* star Anthony Perkins played the role in the movie version. Portions of the movie were filmed at Payne Park, bringing Perkins, Karl Malden, and Hunter to Sarasota during filming. In Tab Hunter's 2006 autobiography, *Tab Hunter Confidential: The Making of a Movie Star*, he revealed that his trip to Sarasota was to visit Perkins, with whom he had a longtime romantic relationship. (Both author's collection.)

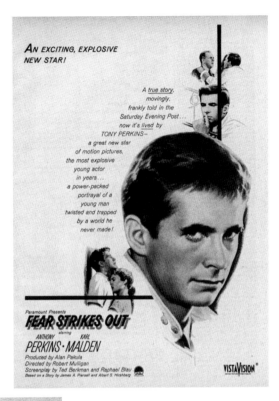

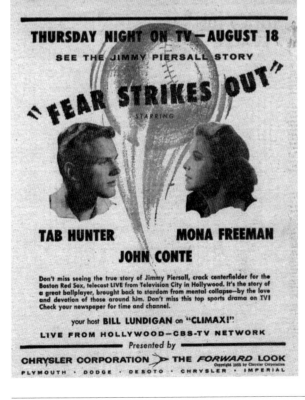

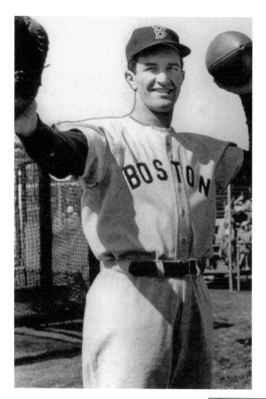

An All-American quarterback at Boston University and a first-round pick of the Cleveland Browns, the multitalented Harry Agganis chose baseball and the Red Sox for his career path. Here, in 1953, he illustrates his versatility at Payne Park. His career came to a sudden and tragic end when the 25-year-old first baseman died of a pulmonary embolism in June 1955. (Courtesy of TNFOTO.)

Ted Williams leaves the Payne Park clubhouse on the first day of spring training in 1954. Williams broke his collarbone when he dove for a sinking line drive off the bat of teammate Hoot Evers. The "Splendid Splinter" did not return to the lineup until mid-May yet went on to hit .345 with 29 home runs and 89 RBIs. (Courtesy of Jack Young.)

Red Sox first baseman Dick Gernett works with coach Jack Burns on his defense at Payne Park. At six feet, three inches and 209 pounds, the right-handed slugger was the prototypical Fenway Park power hitter, slugging 103 homers for the Red Sox in six years as a backup first baseman and left fielder. His best year was 1953, when he hit 21 homers and had 71 RBIs. (Courtesy of REJMJ.)

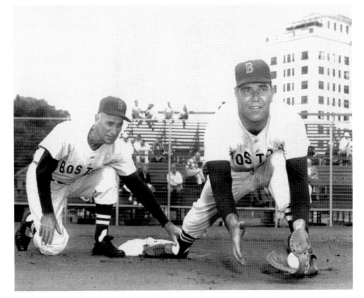

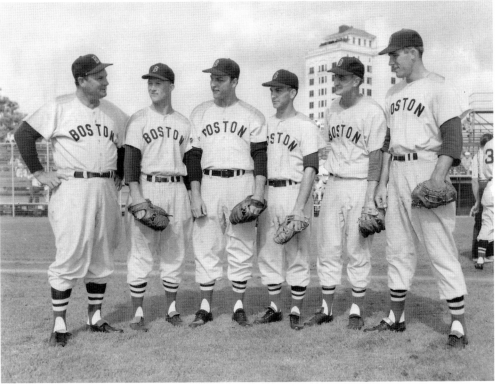

Manager Mike Higgins (left) looks over his rookies in spring training in 1956. All of them played for the Red Sox Triple-A team in Louisville in 1955. From left to right they are outfielder Marty Keough, pitcher Jerry Casale, infielders Don Buddin and Joe Tanner, and catcher Haywood Sullivan. All but Tanner would make it to the big leagues, and Haywood Sullivan became the owner of the team in the 1970s. (Courtesy of REJMJ.)

These two previously unpublished photographs show Ted Williams during spring training in 1957. Known as "The Kid," "Teddy Ballgame," "The Splendid Splinter," and to some "The Greatest Hitter Who Ever Lived," Williams spent 17 springs at Payne Park. Above, Williams (no. 9, center) speaks with someone in the first-base stands, while catcher Pete Daley (no. 8, bottom left) prepares for his turn in the batter's box. An unidentified pitcher warms up, throwing to fellow pitcher Bob Chakales (no. 40) while a coach looks on. The photograph below shows a typical batting-practice session, with Williams taking his cuts in the cage while players watch, wait, field fungoes, and play catch. The 1957 season saw the 38-year-old Williams hit .388, falling just five hits short of hitting .400 for the second time in his career. (Both author's collection.)

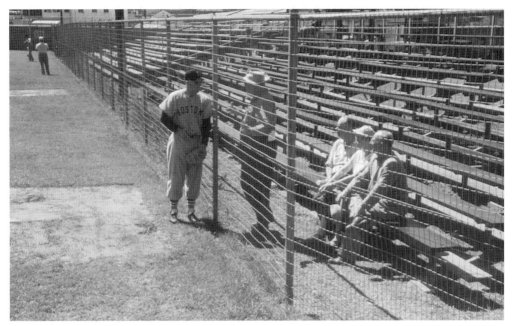

In this 1957 photograph, Red Sox greats Bobby Doerr (in uniform) and general manager Joe Cronin confer through the Payne Park fence. Doerr had retired but remained a special spring-training instructor, while Cronin served as general manager from 1947 until he was elected president of the American League in 1959, a position he held until 1973. Cronin's (4) and Doerr's (1) numbers were retired by the Red Sox. (Author's collection.)

Red Sox second baseman Billy Goodman tests his fishing gear with Michael "Corkey" Cronin, the son of Red Sox general manager Joe Cronin, in the spring of 1954. Goodman played 11 seasons with the Red Sox, from 1947 to 1957. He was twice named to the all-star team, and in 1950 he led the league with a .354 batting average. (Courtesy of REJMJ.)

SPRING TRAINING IN BRADENTON AND SARASOTA

In this 1957 shot, a fan (lower right) watches an unidentified Red Sox pitcher sign an autograph for a Sarasota police officer while two youngsters look on. The player was approached as he made his way from the clubhouse to the field at Payne Park. The 1957 Red Sox were 82-72, good enough for third place, 16 games behind the first-place Yankees. (Author's collection.)

Spring training sometimes involves non-baseball activities. In February 1957, Red Sox pitcher George Susce Jr. married Joanne Marchetti of Wellesley, Massachusetts, at St. Martha's Church in Sarasota. The couple met during a Red Sox-Senators game at Griffith Stadium in 1956. According to Marchetti, it "was love at first sight." They were married for 53 years and had three children. George passed away in June 2010. (Courtesy of REJMJ.)

Marty Keough, seen here leaping for a ball in a posed 1958 Payne Park shot, played 11 seasons in the major leagues, five of them with the Red Sox. A backup outfielder and first baseman, Marty's brother Joe also played for six years in the big leagues. Joe's son Matt pitched in the majors for nine years, most of them with the Oakland Athletics. (Courtesy of REJMJ.)

Training in Sarasota brought advertising opportunities to Red Sox players, which were taken advantage of by Jackie Jensen and others. In this late-1950s advertisement for Florida orange juice, the right fielder extols its virtues. Jensen, the only major leaguer to play in the Rose Bowl (1948) and the World Series (1950), was a member of the Red Sox for seven seasons and was the 1958 MVP. (Author's collection.)

Official Program and Scorecard 14c, Tax 1c, Total 15c

BOSTON RED SOX

THOMAS A. YAWKEY

JOSEPH E. CRONIN

MICHAEL "Pinky" HIGGINS

PAYNE PARK — SPRING TRAINING GAMES — 1958 — SARASOTA, FLORIDA

NEW TERRACE HOTEL

AFTER THE GAME ENJOY AN INNING AT

DRIFTWOOD ROOM

SPECIAL — COCKTAIL OF THE WEEK — 38c
DANCING NITELY
NEXT DOOR TO PAYNE PARK

WILLIAMS, Theodore Samuel (Ted) — Outfielder

G	AB	R	H	TB	RBI	HR	BA	PO	A	E	FA
132	420	96	163	307	87	38	.388	215	2	1	.995

TED WILLIAMS' 1957 BATTING RECORD

Versus	G	Season	Home	Road	Day	Night	BB	SO	HR
Cleveland	18	.474	.467	.481	.595	.250	10	7	1
New York	20	.463	.531	.333	.447	.500	28	7	6
Kansas City	21	.435	.464	.406	.390	.526	22	2	3
Detroit	18	.359	.361	.357	.311	.474	14	9	9
Baltimore	18	.348	.333	.359	.333	.375	17	11	6
Chicago	18	.333	.440	.237	.357	.286	13	6	6
Washington	19	.333	.214	.448	.316	.388	22	7	7

TED WILLIAMS' ALL-STAR RECORD

Year	League	POS.	AB	R	H	TB	RBI	HR	BA	PO	A	E	FA
1940	American	OF	2	0	0	0	0	0	.000	3	0	0	1.500
1941	American	OF	4	1	2	6	4	1	.500	3	0	1	.750
1942	American	OF	4	0	1	1	0	0	.000	0	0	0	.000
1946	American	OF	4	4	4	10	5	2	1.000	1	0	0	1.000
1947	American	OF	4	0	2	3	0	0	.500	3	0	0	1.000
1948	American	PH	1	0	0	0	0	0	.000	0	0	0	.000
1949	American	OF	2	1	0	0	0	0	.000	1	0	0	1.000
1950	American	OF	4	0	1	1	1	0	.250	2	0	0	1.000
1951	American	OF	3	0	1	3	0	0	.333	1	0	0	1.000
1954	American	OF	2	1	0	0	0	0	.000	2	0	0	1.000
1955	American	OF	3	1	1	1	0	0	.333	1	0	0	1.000
1956	American	OF	4	1	1	4	2	1	.250	2	0	0	1.000
1957	American	OF	3	1	0	0	0	0	.000	2	0	0	1.000
All-Star Game Totals			39	10	13	29	12	4	.333	23	0	1	.968

THEODORE S. WILLIAMS

Featuring the SPORTSMAN ROOM, Where Sports Celebrities Meet
HOLIDAY HOUSE
THE MOST FABULOUS RESTAURANT AND COCKTAIL LOUNGE
ON FLORIDA'S WEST COAST
ENTERTAINMENT • DANCING NITELY
Route No. 301 — Corner De Soto Road — SARASOTA For reservations Phone EL 5-5027

Schaffner's
COMPLETE HOME DECORATORS
1507 SOUTH TAMIAMI TRAIL
SARASOTA, FLORIDA Tel. Ringling 7-0950

WARREN'S
LADIES
EXCLUSIVE SHOE STORE
"Where You Find Style and Comfort"
1464 MAIN STREET PHONE RI 7-9470

In July 1958, the Red Sox announced that they had inked a working agreement with Scottsdale, Arizona, and would be moving their spring-training headquarters there. This brought an end to a 25-year relationship with Payne Park and Sarasota. It is said that Ted Williams contemplated retirement after hearing the news, as Arizona would provide no saltwater fishing during spring training for the avid angler. Williams spent only two springs in Arizona, retiring following the 1960 season. Above is the cover of a program from the last Red Sox spring in Sarasota. At left, a page from that same program illustrates the allure of Ted Williams and the Red Sox to business interests in the community, particularly the Terrace Hotel. (Both author's collection.)

Having trained out of the country for two years to stave off the segregated South, the Brooklyn Dodgers built "Dodgertown" in Vero Beach, Florida, for the 1949 season. Totally self-contained, it allowed black and white players to stay together. In July 1958, the Red Sox announced their intention to leave Sarasota for Scottsdale, Arizona. The Dodgers filled the void, scheduling 10 games at Payne Park for the spring of 1959. Interestingly, the 1959 Dodgers met the next Payne Park occupants, the Chicago White Sox, in the 1959 World Series. The Dodgers, in only their second year in Los Angeles, defeated the White Sox in six games. The following spring, in 1960, the White Sox began training at Payne Park, beginning a relationship with Sarasota that lasted nearly four decades. (Both author's collection.)

Bill Veeck, seen in both these 1960 Payne Park photographs with circus performers from the Ringling Circus, purchased the White Sox in 1959. They went on to win the American League pennant that year, setting attendance records in Chicago that year and again in 1960. One of baseball's great innovators, Veeck lost his leg while serving in the South Pacific in World War II. As owner of the Cleveland Indians, he signed Lary Doby, the American League's first black player, in 1947. He is responsible for Comiskey Park's exploding scoreboard and for names on the backs of players' jerseys. Veeck also urged White Sox broadcaster Harry Caray to sing "Take Me Out to the Ballgame" live during the seventh-inning stretch. Veeck sold the team in 1961, repurchased it in 1975, and sold it again in 1981. (Both courtesy of SCHC.)

Manager Al Lopez and owner Bill Veeck look over their new facility at Payne Park in the spring of 1960. Lopez took the helm of the White Sox in 1957 and managed them until 1965, returning for the 1968 and 1969 seasons. He was 840-650 with the Sox and piloted them to the 1959 World Series. He was inducted into Cooperstown in 1977. (Courtesy of REJMJ.)

White Sox pitcher Joel Horlen laces up his cleats in the Payne Park clubhouse in 1961 as an unidentified teammate reaches for his shoe. Horlen pitched for the White Sox from 1961 through 1971. His best year was 1967, when he was 19-7, led the league with a 2.06 ERA, and finished second in the voting for the Cy Young Award behind Boston's Jim Lonborg. (Courtesy of SCHC.)

A solitary figure finishes dressing in the clubhouse at Payne Park in 1960, the inaugural White Sox season at the Sarasota facility. The White Sox only moved a few miles south, having trained in Tampa from 1954 through 1959, and arrived in Sarasota as the reigning American League champs. (Courtesy of SCHC.)

Signing baseballs in front of his locker is 23-year-old Gary Peters, who was the American League Rookie of the Year in 1963, when he went 19-8 and led the league with a 2.33 ERA. Peters was 91-78 in 11 years with the White Sox and enjoyed 10 springs in Sarasota's Payne Park. Today, he calls Sarasota home. (Courtesy of SCHC.)

In these two photographs, White Sox pitcher Early Wynn poses in the outfield of Payne Park. Note the bunting along the grandstand in the background, indicating the first game of spring training. Wynn pitched for 23 years in the big leagues, including five with the White Sox, from 1958 through 1962. He is one of 24 pitchers in major-league history to amass 300 career wins and was a longtime resident of Nokomis, Florida, just down the road from Payne Park. In the White Sox pennant-winning 1959 season, he was 22-10, leading the American League in wins. (Both courtesy of SCHC.)

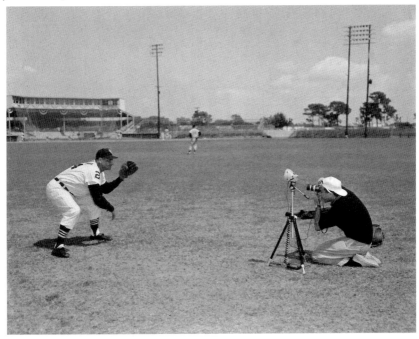

The White Sox arrived in Sarasota with a double-play combination destined for the Hall of Fame. Second baseman Nellie Fox (below) was the 1959 MVP and shortstop Luis Aparicio (left) was the runner-up, and that year they each won a Gold Glove. With Aparicio leading off and stealing a league-leading 56 bases and Fox the prototypical no. 2 hitter, the pair drove the "Go Go Sox" to the top of the American League in 1959. Aparicio was the 1956 Rookie of the Year and a 10-time all-star with three teams. Fox, who Ted Williams called the smartest player he ever knew, was a 12-time all-star. Aparicio was inducted into the Hall of Fame in 1984, becoming the first native-born Venezuelan to achieve that honor. Fox joined him in Cooperstown in 1997. (Both courtesy of REJMJ.)

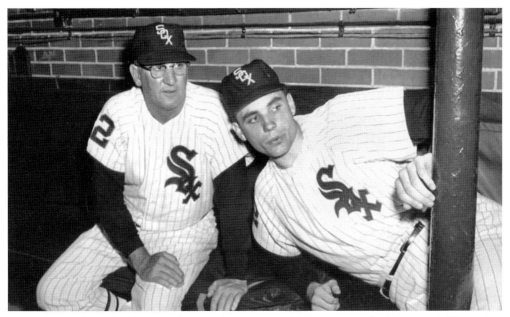

Dave DeBusschere (right), seen here with manager Al Lopez, was a highly touted White Sox pitching prospect. He also played in the NBA for the Detroit Pistons, and in 1965 he devoted himself strictly to basketball. Traded to the Knicks in 1968, he was the final piece to their championship puzzle, and they won NBA titles in 1970 and 1972. He is an NBA Hall of Famer and was named one of the 50 greatest players in NBA history in 1996. (Courtesy of REJMJ.)

Orestes "Minnie" Miñoso became the first person of color to play for the Chicago White Sox when he joined the team on May 1, 1951. He was traded to Cleveland in 1957 and then traded back to Chicago in 1959, so he was with the White Sox when they ventured to Sarasota in 1960. Miñoso was a pioneering player, breaking down racial barriers with Bill Veeck's Cleveland Indians as well, before rejoining Veeck in Chicago. (Courtesy of REJMJ.)

Bill "Moose" Skowron played 14 seasons in the majors, nine with the Yankees and four at the end of his career with the White Sox. One of the most likeable men to ever play the game, "Moose" was an all-star with Chicago in 1965, when he hit .274 with 18 home runs and 78 RBIs, leading the team in both categories. (Courtesy of REJMJ.)

Hoyt "Old Sarge" Wilhelm pitched for 21 years with nine different teams. From 1963 to 1968, when he was in his 40s, he spent six seasons with Chicago—more years than with any other team. Seen at Payne Park, "Old Sarge" shows his knuckleball to catcher Sherm Lollar (right) and pitcher Eddie Fisher (left). He had 143 wins and 227 career saves. Inducted into Cooperstown in 1985, Wilhelm retired to Sarasota and was laid to rest there in 2002. (Courtesy of REJMJ.)

"Beltin' " Bill Melton, seen here emerging from the Payne Park dugout around 1970, played eight years with the White Sox, from 1968 through 1975. His best year came in 1971, when the third baseman led the American League with 33 home runs and made the all-star team. (Courtesy of REJMJ.)

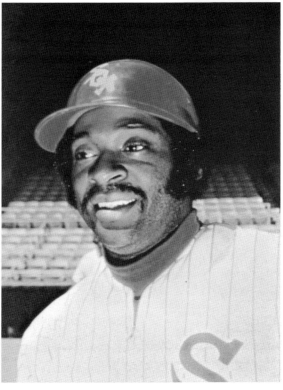

Acquired from the Dodgers for the 1972 season, Dick Allen missed his first Payne Park spring training holding out before becoming the highest-paid White Sox player in their history. The 1972 MVP, he captured two-thirds of the Triple Crown, with 37 home runs and 113 RBIs. Many baseball historians believe he is the best player not in the Hall of Fame. (Courtesy of REJMJ.)

Rich "Goose" Gossage earned the save in the first-ever game where players wore shorts. Ever the promoter, Veeck saw that after the third "shorts game," the attire was not mentioned anywhere in newspaper game accounts, and he never did the promotion again. When Gossage was inducted into the Hall of Fame in 2008, he became the only player in the hallowed hall to have worn shorts in a game. (Courtesy of Joe Karamax.)

Wilbur Wood (right) had pitched in parts of six seasons with the Red Sox and Pirates when he joined the White Sox in 1967. He developed a knuckleball and went on to write White Sox history as the only pitcher to win 20 games for four straight years. Here, he gets a Payne Park run-in with Clay Carroll in his last spring training in March 1978. (Courtesy of REJMJ.)

The 1982 spring found the White Sox with a new logo and in a brand-new clubhouse courtesy of the City of Sarasota and the Chicago White Sox Sarasota Sports Committee. Both were displayed on the spring-training programs. The 1982 spring training marked the 23rd year at Payne Park, making them Payne Park's longest tenant. (Author's collection.)

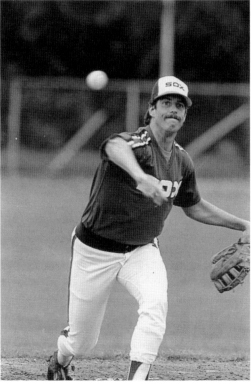

White Sox right-hander Jim Siwy throws a pitch towards home plate during a workout at Payne Park in 1983. The Sox had high hopes for the 1980 third-round draft pick. He was 28-12 in his first two years in the minor leagues; however, his big-league career consisted of only 11 1/3 innings in parts of two seasons. (Courtesy of REJMJ.)

In 1983, the Chicago White Sox introduced aerobic exercises and the radical concept of having them led by a woman (above). Tony La Russa (below) was 34 years old when he took the reins of the Chicago White Sox in 1979. Ever the innovator and always looking and thinking outside the box, he was one of the first to institute aerobic workouts as part of the team's conditioning. As the photograph indicates, he was always an active participant, and his efforts paid off, as the White Sox won the American League West in 1983. It was La Russa's innovative thinking that in just a few short years introduced the "closer" to baseball in the person of Dennis Eckersley. (Both courtesy of REJMJ.)

In his third year with the White Sox, catcher Carlton Fisk dedicated himself to a rigorous workout regimen that included aerobics and vigorous weight training. He would very often lift weights in the Comiskey Park weight room after a night game. In 1983, he finished third in the balloting for the American League MVP. (Courtesy of REJMJ.)

In this photograph, two unidentified White Sox pitchers "get into" their calisthenics workout prior to baseball at Payne Park in 1983. The music blared through the Payne Park speaker system as the players worked on Tony La Russa's new workout system. It is clear that these two players enjoyed "rocking out" on the field. (Courtesy REJMJ.)

It is clear that even in the midst of training, conditioning, and workouts, there are fun and playful times. Carlton Fisk of the 1983 White Sox gets a visit and some encouragement from man's best friend as he pauses during calisthenics in the Payne Park outfield. (Courtesy of REJMJ.)

A relic from days gone by, this sign once directed fans to Payne Park from Sarasota's Route 41. The White Sox left Payne Park in 1988 and moved into the new Ed Smith Stadium across town. The White Sox left Sarasota for Tucson, Arizona, in 1998. (Courtesy of SCHC.)

It was a Payne Park tradition to paint the spring schedule on the brick wall facing the parking lot behind home plate. It was the first thing seen by patrons entering the front gate. In this photograph, the wall sports the 1987 spring schedule, which featured four visits from the Pirates, including the opening and closing games. (Courtesy of SCHC, James Johnson collection.)

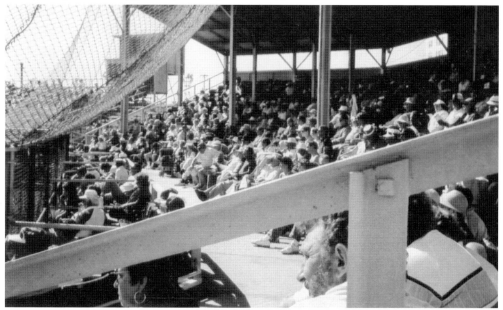

Fans watch from behind the plate at Payne Park in a 1987 spring game. The roof behind the plate provided the only covering in the ballpark. The shaded seats were the most desired, as they provided a break from the Florida sun, which can be oppressive even in spring. (Courtesy of SCHC, James Johnson collection.)

When Carlton Fisk played for the Red Sox, he wore number 27. Upon signing with the White Sox, he turned it around and wore number 72, opening up his old number to young catcher Mark Salas, seen here (center) sharing a word with Fisk (left) and pitching coach Dyar Miller (49) during a Payne Park game in 1988, the park's last season. (Courtesy of SCHC, James Johnson collection.)

White Sox first baseman Greg Walker signs autographs for the crowd outside of Payne Park during a spring training game in 1987. Walker spent nine years in the major leagues, eight of them with the White Sox, and was their regular first baseman in 1985. (Courtesy of SCHC, James Johnson collection.)

The grandstands at Payne Park were often a source of refuge from the hot Florida sun. In these two photographs, some White Sox opponents find respite in the shade during the 1987 spring training season. Above, relief pitcher Willie Hernandez and his teammates cool down, and below New York Mets outfielder Lee Mazzilli (right) chats with an unidentified Mets coach. In 1984, Hernandez made history when he became only the fifth pitcher and second relief pitcher to win both the Cy Young and MVP Awards. He was 9-3 with a 1.92 ERA and 32 saves. Mazzilli spent 14 years in the major leagues, 10 of them with the Mets, where he made the 1979 National League all-star team. (Both courtesy of SCHC, James Johnson collection.)

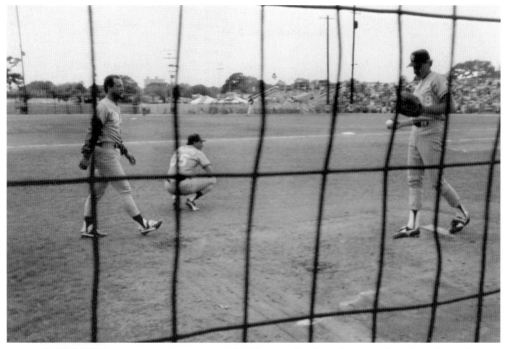

In this photograph, taken through the netting near the visitors' bullpen at Payne Park, Kansas City Royals Hall of Fame third baseman George Brett strolls past while Royals ace reliever Dan Quisenberry warms up for a 1987 spring game. Brett was a three-time batting champ, while "Quiz" led the American League in saves five times during the Royals' glory days of the 1980s. (Courtesy of SCHC, James Johnson collection.)

This shot of the third-base visitors' dugout at Payne Park shows Cincinnati Reds manager Pete Rose standing at the far end. Rose managed the Reds for six years, the first two as player-manager. During his managing tenure, he was found to have bet on baseball games, resulting in his permanent banishment from the game. (Courtesy of SCHC, James Johnson collection.)

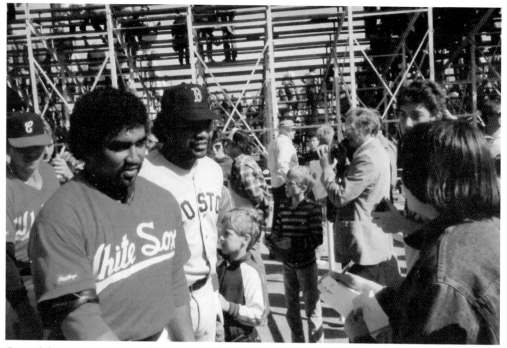

One of the unique aspects of Payne Park that is now gone from the modern spring-training parks is the fans' proximity to the players. These two photographs clearly illustrate that point. Above, in a spring game in 1987, Red Sox outfielder Dave Henderson walks through the crowd at Payne Park with his White Sox counterpart Iván Calderon; below, Red Sox outfielder Dwight Evans does the same on his way to the visitors' clubhouse. The Red Sox and White Sox were the tenants of Payne Park for 52 of its 65 years. (Both courtesy of SCHC, James Johnson collection.)

Steve Lyons earned the nickname "Psycho" for his on-field and off-field antics while playing for nine years on four teams, including the White Sox. A utility player, he even gave catching a shot and is seen here toting his catcher's gear through a Payne Park crowd following a spring training game in the late 1980s. (Courtesy of SCHC, James Johnson collection.)

Catcher Carlton Fisk was the signature player for the Chicago White Sox for 13 years. After joining them in 1981, Fisk was a four-time all-star and won the Silver Slugger Award as the American League's best-hitting catcher three times. Here, he signs autographs as he makes his way through the Payne Park crowd following a 1987 spring-training game. (Courtesy of the SCHC, James Johnson collection.)

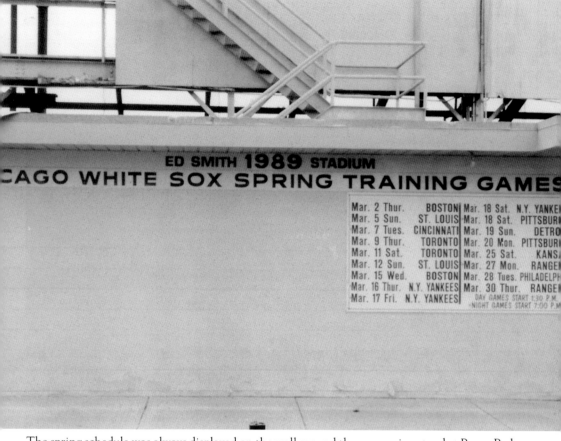

The spring schedule was always displayed on the wall around the concession stand at Payne Park. This 1988 photograph serves as an obituary for the park, which had housed spring-training games since Calvin Coolidge occupied the White House. Stark in its simplicity, it announces the 1989 schedule. Payne Park had seen the games all-time greats, from Hornsby, Terry, McGraw, and Ruth to Grove, Foxx, and Williams. It had served as the spring home for Hall of Famers Nellie Fox, Luis Aparicio, Hoyt Wilhelm, and Early Wynn. It served as a training ground for manager Tony La Russa, who is sure to enter Cooperstown as one of the game's greatest managers, and it carried Carlton Fisk to Ed Smith Stadium, where Frank Thomas made his appearance. (Courtesy of SCHC.)

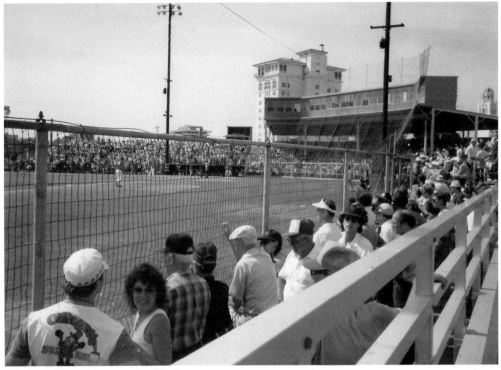

These two photographs were taken in the late 1980s and capture the flavor of Payne Park, which permeated the field for six decades. The image above shows the grandstand behind home plate and could have been taken anytime from the 1920s to the 1970s. The photograph below was taken from down the left-field line and shows the antiquated press box. The building, which looms over the field, was a part of the Payne Park landscape throughout its entire 65-year existence. The ever-present edifice was originally the Terrace Hotel, which housed early teams, and is now the Sarasota County Administration Building. It is as much a part of the Payne Park story as the park itself. (Both courtesy of SCHC, James Johnson collection.)

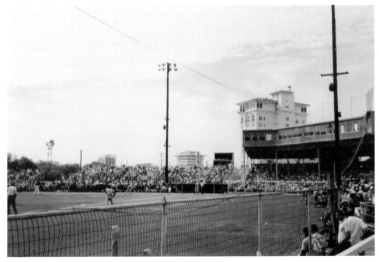

The last Payne Park spring-training game was played on March 30, 1988, between the White Sox and the Texas Rangers. In 1989, the White Sox moved into their new spring-training facility at Ed Smith Stadium across the city. Payne Park was demolished in 1990. In the span of six and half decades, more than 1,000 spring-training games were played on this field, with the greats of every era participating. For local prep players, it could not get better than playing a game on the Payne Park diamond. This photograph of an abandoned Payne Park prior to demolition is a poignant portrayal of the end of an era. (Courtesy of SCHC.)

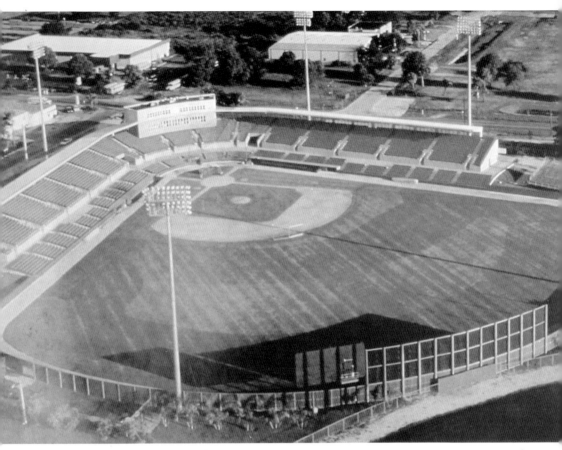

As Payne Park was being laid to rest, the construction of its replacement was ongoing. In this aerial 1990 photograph, the finished product is on display. This overview was taken from directly above the four-field minor-league complex just beyond center field. Named after Sarasota Sports Committee president Ed Smith, who served in that capacity from 1966 to 1993, the park opened in 1989, with White Sox lefty Jerry Reuss pitching the first pitch to Wade Boggs. It was appropriate that the White Sox hosted the Red Sox in the first game at the new park, as those two teams dominated Sarasota spring training at Payne Park. Throughout the years, the stadium has also played host to a plethora of amateur events, including the Florida High School State Championship playoffs. (Author's collection.)

4

ED SMITH STADIUM

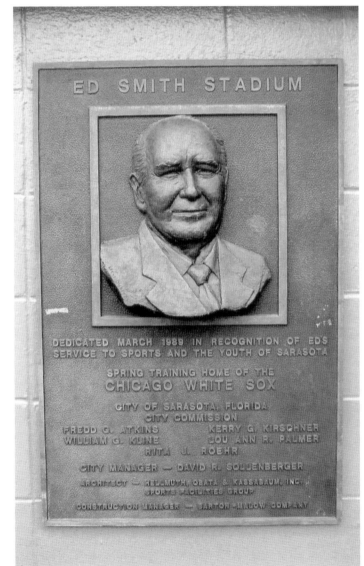

Ed Smith Stadium was dedicated in March 1989, and this plaque was put in place honoring the park's namesake. It was largely through the efforts of Ed Smith that the stadium was built, and it has hosted the Chicago White Sox, the Cincinnati Reds, and the Baltimore Orioles in 23 years. It has also been home to the Sarasota White Sox, the Sarasota Red Sox, and the Sarasota Reds of the Florida State League, as well as the Gulf Coast League Reds. (Courtesy of Jamie Wisner.)

This view of third base comes from the left-field section of Ed Smith Stadium in its inaugural year. Although it holds considerably more fans than Payne Park, it is clear to see that the charm and "coziness" that characterized the older facility is missing. That charm would be incorporated in the renovation that brought the Orioles to town in 2011. (Courtesy of SCHC, James Johnson collection.)

In a photograph that is indicative of a different era, the sign amidst Ed Smith's four minor-league fields urges fans to return any baseballs that may leave the parks. Today, there seems to be a never-ending supply of baseballs, which are given to fans in numbers that would have the owners of yesteryear shuttering. (Courtesy of SCHC.)

Texas Rangers manager Bobby Valentine and pitching coach Tom House watch from the Ed Smith dugout during a game in the stadium's inaugural 1989 season. Valentine managed the Rangers for eight years, from 1985 through 1992, and then managed the Mets through the 2002 season. He took the helm of the Boston Red Sox in 2012 and was fired after one season—Boston's worst since 1965. (Courtesy of SCHC, James Johnson collection.)

The 1972 Rookie of the Year with the Red Sox and the author of one of baseball's most dramatic moments, Carlton Fisk became a free agent in the winter of 1980. Signing with the White Sox, he turned his number around to 72 and played 13 seasons in the Windy City. He was the White Sox bridge from Payne Park to Ed Smith Stadium, where he is seen here around 1990. (Courtesy of SCHC, James Johnson collection.)

Another slugger, Albert Belle, joined the White Sox in 1997 for their final year in Sarasota. Seen here stretching on the Ed Smith diamond, Belle spent only two years with Chicago but hit 79 home runs and knocked in 268 runs. Even with such a short stint with the White Sox, he holds single-season team records for doubles, home runs, RBIs, total bases, and grand slams, as well as home runs in one month. (Author's collection.)

Perhaps nothing generated as much excitement at Ed Smith Stadium as Michael Jordan's attempt to become a major-league baseball player. Forsaking the Chicago Bulls, he announced his retirement from basketball in 1994 and signed a minor-league contract with the White Sox. Here, he stops to chat with a fan as he makes his way to the Ed Smith clubhouse in 1994. (Courtesy of Thom Sheridan.)

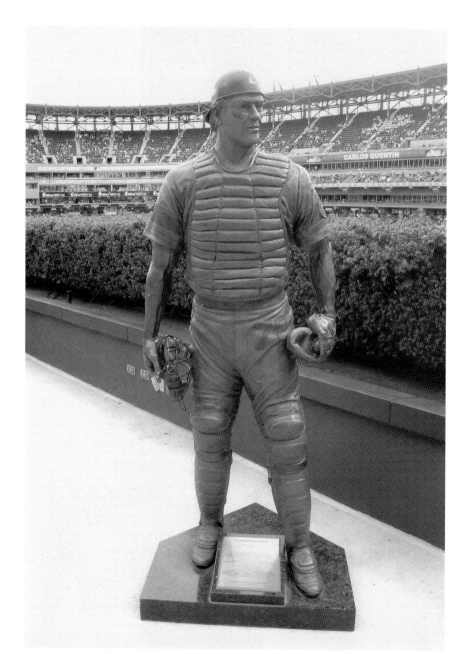

After 13 years with the Chicago White Sox, Carlton Fisk was honored by the White Sox with this bronze statue at US Cellular Field in Chicago. He was a four-time all-star with Chicago and won the Silver Slugger Award three times with them. Inducted into Cooperstown in 2000, "Pudge" is one of only nine individuals in history to have his number retired by more than one team. The others are Reggie Jackson, Frank Robinson, Rod Carew, Greg Maddux, Rollie Fingers, Hank Aaron, and Casey Stengel. Nolan Ryan is the only player to have his number retired by three teams. Still a winter resident of Sarasota, Fisk runs a golf tournament to benefit local charities. (Courtesy of Mark Yearian.)

Arriving at Ed Smith Stadium in 1990, Frank Thomas was an immediate star, hitting .318 with 32 home runs and 109 RBIs in 1991. He won back-to-back MVP Awards in 1993 and 1994, was five times an all-star, and replaced Carlton Fisk as the White Sox's signature player. Playing 16 of his 20 seasons in a White Sox uniform, he hit 448 of his 521 career homers with Chicago, and in 2010 he became the ninth White Sox player to have his number retired when his 35 joined the list of immortals. Playing at a time when steroid use was running rampant in major-league baseball, "The Big Hurt" was never linked to usage. He is destined for the Hall of Fame and will appear on the ballot for the first time in 2013. (Courtesy of REJMJ.)

When the White Sox left for Arizona, it paved the way for the Cincinnati Reds, who arrived at Ed Smith Stadium in 1998. The press box reflected their history with the display of retired numbers: Dave Concepción (13), Fred Hutchinson (1), Johnny Bench (5), Joe Morgan (8), Sparky Anderson (10), Ted Kluszewski (18), Frank Robinson (20), Tony Pérez (24), and of course Jackie Robinson's number 42. (Courtesy of David Lewicki.)

The Reds mascot, Mr. Red, became a staple at Ed Smith Stadium and was often found on the field and roaming the stands. Here, during a spring game in 2006, he encountered a Florida Gator in the stands. Luckily for him, the gator was a Reds fan as well, and they were able to work out their differences. (Courtesy of Jamie Wisner.)

SPRING TRAINING IN BRADENTON AND SARASOTA

One of the great attractions Cincinnati brought to Ed Smith Stadium was the player who came to be known simply as "Junior." Ken Griffey Jr. played with the Reds for nine years, hitting 210 of his 630 career homers in a Cincinnati uniform. He is seen here stretching on the Ed Smith diamond with teammate Austin Kearns before a spring-training game. (Courtesy of Jamie Wisner.)

With Junior on the downside of his career, Reds first baseman Joey Votto emerged as the new face of the Cincinnati Reds franchise. Here, Votto digs into the Ed Smith batter's box in a 2011 spring game. In his six years with the Reds, Votto has been named to three all-star teams and was the National League MVP in 2010. (Courtesy of Jamie Wisner.)

New York Yankees captain Derek Jeter has been a regular visitor to Ed Smith Stadium for two decades. He has played at Ed Smith against the White Sox, the Reds, and the Orioles. Here, he stands behind the batting cage waiting for his turn as he and his Yankees prepare for a 2005 spring-training game against the Reds. (Courtesy of Jamie Wisner.)

The Reds departed to Arizona after 2009, and the Baltimore Orioles signed a 30-year lease with Ed Smith Stadium. The lease included a $31.5 million renovation, which was completed before the 2011 spring-training season. The Orioles championship banners are on display in the Ed Smith concourse (below). (Courtesy of Stu Kreisman.)

In a stark contrast to the days of limited baseballs, a Baltimore Orioles coach reaches into the "hopper" for a baseball to loosen up with as he prepares to be the first pitcher for the Orioles batting practice at Ed Smith Stadium in March 2012. A major-league team uses an average of just under 200,000 baseballs in a season. (Author's collection.)

Below, under the watchful eye of the Baltimore Oriole, the Boston Red Sox stretch on the Ed Smith Stadium field as they prepare to take on the Orioles on St. Patrick's Day in 2012. The Orioles displaced the Red Sox as a power in the American League East, winning 93 games and capturing the Wild Card before losing to the Yankees in the League Division Series in five games. (Author's collection.)

In 2013, the Baltimore Orioles will be in the fourth year of a 30-year lease with Sarasota. They have long had a relationship with Sarasota, as their minor leaguers have trained and played at the "Buck" O'Neil complex in Sarasota's Twin Lakes Park facility since 1991. The complex was named for baseball great and Sarasota native John "Buck" O'Neil. The year 2012 brought the Orioles their first winning season and postseason berth since 1997. Their lease assures that the city of Sarasota will have spring training until at least 2039, when baseball will celebrate its 200th birthday and Sarasota will celebrate its 117th year of spring training. (Author's collection.)

BIBLIOGRAPHY

Bryant, Howard. *The Last Hero: A Life of Henry Aaron*. New York: Pantheon Books, 2010.
Hickey, David, Raymond Sinibaldi, and Kerry Keene. Images of America: *Fenway Park*. Charleston, SC: Arcadia Publishing, 2012.
LaHurd, Jeff. *Spring Training in Sarasota, 1924–1960*. Charleston, SC: The History Press, 2006.

DISCOVER THOUSANDS OF LOCAL HISTORY BOOKS
FEATURING MILLIONS OF VINTAGE IMAGES

Arcadia Publishing, the leading local history publisher in the United States, is committed to making history accessible and meaningful through publishing books that celebrate and preserve the heritage of America's people and places.

Find more books like this at
www.arcadiapublishing.com

Search for your hometown history, your old stomping grounds, and even your favorite sports team.

Consistent with our mission to preserve history on a local level, this book was printed in South Carolina on American-made paper and manufactured entirely in the United States. Products carrying the accredited Forest Stewardship Council (FSC) label are printed on 100 percent FSC-certified paper.

MADE IN THE USA